INTRODUCTION TO
DIGITAL
PHOTOGRAPHY

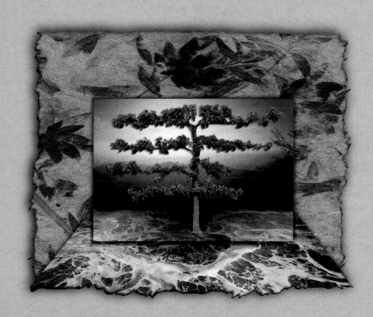

JOSEPH CIAGLIA

Prentice
Hall

Upper Saddle River, New Jersey 07458

Library of Congress Cataloging-in-Publication Data

Ciaglia, Joseph
 Introduction to digital photography / Joseph Ciaglia.
 p. cm.
 Includes bibliographical references and index.
 ISBN 0–13–032136–2
 1. Photography—Digital techniques. 2. Image processing—Digital techniques. 3. Digital Cameras I. Title

 TR267.C53 2002
 778.3–--dc21 2001036465

Editorial Director: Charlyce Jones Owen
AVP, Publisher: Bud Therien
Assistant Editor: Kimberly Chastain
VP, Director of Production and Manufacturing: Barbara Kittle
Production Editor: Harriet Tellem
Director of Marketing: Beth Gillett Mejia
Marketing Manager: Chris Ruel
Prepress and Manufacturing Manager: Nick Sklitsis

Prepress and Manufacturing Buyer: Sherry Lewis
Creative Design Director: Leslie Osher
Art Director / Cover and Interior Design: Kathryn Foot
Electronic Page Layout: Rosemary Ross
Line Art Manager: Guy Ruggiero
Line Art Coordination: Mirella Signoretto
Electronic Art Coordination: Scott Garrison
Cover Art: Katrin Eismann, *Looking East*

This book was set in 10/13 Futura Book by HSS inhouse formatting and production group, and was printed and bound by Phoenix Color Corp., Rockaway, NJ. The cover was printed by Phoenix Color Corp.

© 2002 by Pearson Education, Inc.
Upper Saddle River, New Jersey 07458

Printed in the United States of America
10 9 8 7 6 5 4 3 2 1

ISBN 0-13-032136-2

Pearson Education LTD, London
Pearson Education Australia PTY, Limited
Pearson Education Singapore, Pte. Ltd
Pearson Education North Asia Ltd
Pearson Education Canada, Ltd.
Pearson Educación de Mexico, S.A. de C.V.
Pearson Education -- Japan
Pearson Education Malaysia, Pte. Ltd
Pearson Education, Upper Saddle River, New Jersey

CONTENTS

CHAPTER 4 *Basic Image Editing* 42

APPENDIX *Recent Developments in Imaging Software* *106*

This book is written for students who have had at least one semester of traditional black-and-white photography. It links what students have learned about traditional photography with the basics of digital photography.

This book results from an exploration into the needs of teachers and beginning students in this new field. The author realized that nearly all the successful books about digital imaging fall into two camps. Some texts are aimed at experienced photographers. Others are encyclopedic software manuals about Adobe Photoshop that give excellent descriptions of every proverbial "tree," but no overview of the "forest." Neither kind of book provides what beginning students need. Beginners need a logical starting place and guidance about what is essential and what is less important.

A truly useful basic textbook about digital imaging would be one that takes the revolutionary step of not being encyclopedic; it would be one that presents principles and essentials. Consequently, this book focuses on the most broadly useful aspects of Photoshop, and demonstrates, with numerous illustrations, how the most important tools work together to make the software a powerful whole. An example of essential tools working together is the use of masks on adjustment layers. (See pages 79, 84, and 87).

The choice of topics places a strong emphasis on the photographic qualities of imaging software. The makers of Photoshop have added excellent vector graphics capabilities and expanded page/web layout and word processing features to their software. Professional users demand these features, but a school curriculum that is photographic at its core needs a basic textbook that stays focused on the photographic fundamentals.

Clarity of presentation is the uppermost value in the organization of this book. We wanted to organize the presentation to be both logical and interesting.

- An easy-to-use format is employed in which facing pages present a single idea, process, or family of software tools.

- Boldfaced topic sentences organize the topics on every page.

- Numerous color illustrations enhance the teaching power of the book. The illustrations were created or chosen to motivate the learner to want to learn the techniques discussed in the text.

- Whenever possible, topics in digital imaging are related to similar topics in the traditional basic photography curriculum.

- Complex operations such as scanning, creating composite images, and resampling images are presented as illustrated step-by-step procedures. The logical, easy-to-follow sequences of each procedure are clearly explained.

- Projects are given that are suitable for individuals or whole classes.

Without the help and experience of many others, an author cannot complete a book like this. Barbara London proposed and championed the project, and her knowledge of every aspect of

creating a textbook helped the author in ways beyond measure. Sheena Cameron gave level-headed perspective and warm support when it was most needed. Craig Collins helped with ideas about how to explain the ins and outs of Photoshop. Peggy Jones' years of experience with teaching several digital subjects provided a context for thinking about how students experience Photoshop. Bonnie Kamin helped when many additional illustrations were needed. M.K. Simqu helped with more insights about how people learn Photoshop. Fellow photography author Jim Stone helped with structuring the project in its difficult early stages. The many photography teachers who spoke with me about their experiences and the dozens more who contributed essays about teaching digital imaging to the book *Magic Wand* all helped in innumerable ways.

Producing a book requires professionalism. Editors and production chiefs from HarperCollins and later, Prentice Hall were extremely helpful to the author: Kimberly Chastain, Priscilla McGeehon, Harriet Tellem, and Bud Therien.

The classroom is the best test of ideas about teaching. This book is dedicated to my Digital Imagery I and II students at the University of New Mexico, Taos.

INTRODUCTION TO

DIGITAL PHOTOGRAPHY

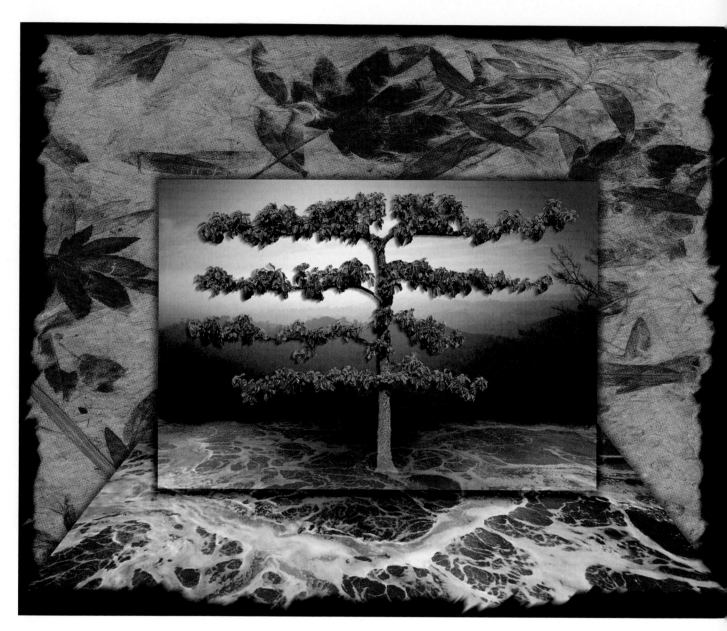

COLOR PHOTOGRAPHY

For nearly 100 years after the invention of photography, photographers wished they could capture the colors they saw, but it was not until 1935 that the first easy-to-use and practical color film, Kodachrome, was developed. Within a few years many kinds of negative and positive (reversal or slide) color films were available to amateurs as well as to professional photographers.

In this chapter you'll learn how film captures colors and how color images are created. You'll learn about negative and positive films and the advantages of different types of film. You'll learn how to choose the right type of film for different lighting conditions, and you'll learn how to use colored filters to correct imbalances between light and film.

Digital imaging has created new opportunities for photographers. Although color darkroom processes have been available for decades, making color prints has never seemed as quick or as easy as black-and-white printing. The emergence of computers and image-editing software in the late 1980s and the appearance of inexpensive, photo-realistic digital printers in the late 1990s changed that; digital printing is now as convenient as black-and-white darkroom printing. Powerful imaging software makes it easy to transform color images in ways that are difficult or impossible in a darkroom. In chapters 2 through 6 you'll learn how your color images can be processed and printed in the new digital darkroom.

Opposite **KATRIN EISMANN** Looking East

The first half century of color photography was a time when the photographic industry worked to create films that recorded the colors of the world with greater and greater accuracy. The second half century of color imaging may be one in which the expressive and imaginative use of color is the primary goal of photographic artists.

Katrin Eismann combined a digital scan of traditional Japanese paper with photographs of a tree, ocean waves, and a mountain scene to create a fantasy landscape. Digital imaging gives photographers the complete freedom in choosing colors that painters have enjoyed for thousands of years. Here the artificially violet sky behind the tree is helpful to the image. An "accurate" sky (a sky with blues and cyans) would weakly contrast with the muted warm tones of the paper background.

Color: Additive and Subtractive

Colored images can be created by adding primary colors together or by subtracting primary colors from white light. The first color photographic processes made use of additive color, but in the last 60 years subtractive processes have been the choice of photographers and printers.

Additive color mixes light of the primary colors red, green, and blue, (called the RGB colors) to create all possible colors. When equal amounts of red, green, and blue light are mixed the result appears white. Television tubes and computer monitors are the most common examples of additive color systems.

Subtractive color processes use inks or dyes of the primary colors cyan (blue-green), magenta (a purplish pink), and yellow (called the CMY colors). The three CMY colors are complementary to, or opposite, the RGB colors used on the color wheel shown below.

When white light (which contains all colors) shines on paper (or passes through film), the CMYK inks or dyes absorb their opposite colors. Cyan ink absorbs red light, thus subtracting red from the image. Magenta absorbs green, and yellow absorbs blue.

In the additive process, three beams of colored light combine to produce all other colors. Green plus blue produces cyan, blue plus red produces magenta, and red plus green produces yellow. White is produced when all three colors mix in equal amounts.

In the subtractive process, colors are produced when dyes or inks absorb color. Inks of the three subtractive primaries—cyan, magenta, and yellow—here overlap on a white sheet of paper. White light, the illumination, is a mixture of all wavelengths of light. Where the cyan and magenta inks overlap, they absorb red and green; only blue is reflected from the paper. Where magenta and yellow overlap, only red is reflected. A mixture of yellow and cyan inks reflects only green. If inks of all three colors are mixed, all the light is absorbed and the paper appears black. Color film uses the same principle; layers of dye absorb light as it passes through the film.

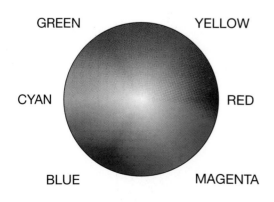

GREEN YELLOW

CYAN RED

BLUE MAGENTA

Left, the color wheel used in photography, printing, and computer monitors. Red, green, and blue (RGB) are primaries in additive systems like television. Cyan, magenta, and yellow (CMY) are the subtractive primaries in photography and printing processes.

Three Image Layers Create Color Images

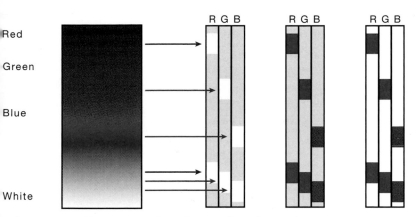

Red

Green

Blue

White

Color negative film contains three layers of emulsion. Each layer is sensitive to one color: red, green, or blue.

a. During exposure, an invisible latent image forms in each layer where light strikes the film.

b. When negative film is developed, a negative silver image plus a negative colored dye image forms in each layer. Cyan dye forms wherever the film was exposed to red light, magenta dye forms wherever the film was exposed to green light, and yellow dye wherever there was blue light.

c. After development, bleach and fixer baths dissolve the silver in the layers. Only colored dyes remain in the film, forming the image.

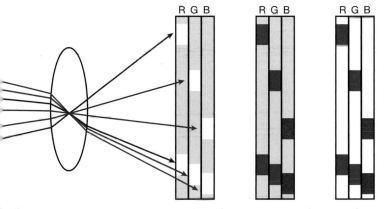

Color negative printing paper employs the same principles as color negative film.

a. During printing, light from the enlarger passes through the color negative. Wherever dyes are present, only light that is the same color as the dye can pass through the film to expose the paper. A latent image forms in the paper.

b. During development, a negative dye image forms in each layer along with a silver negative. This is identical to the way color film develops.

c. After bleaching and fixing, only dye remains in each layer. Since the film image was a negative, the negative dyes in the photographic paper create a positive image.

Color films are either positive (reversal) or negative. Reversal films create images that can be viewed directly, such as color slides. The images in color negative films, like those in black-and-white negative films, must be printed to be viewed. Almost all reversal films are developed with Kodak's E-6 process. Color negative films are developed with Kodak's C-41 process.

A color photograph begins as three superimposed layers of light-sensitive silver-halide emulsion. The layers are like the emulsions in black-and-white film, except that each layer responds only to one primary color: red, green, or blue. Additional layers are added to improve the color response of the three basic layers.

When a color negative is developed, the exposed light-sensitive silver halides in each layer are converted into a metallic silver negative. At the same time, the developer oxidizes and combines with the dye-forming chemicals built into the layer. Thus a color dye image appears in proportion to the amount of developed silver in each layer. The silver is then bleached out, leaving only a negative dye image.

In color reversal film, there are extra steps. The film is developed to make a silver negative first, but no color dyes are produced. A second developer chemically exposes and develops the remaining unexposed silver halide, thus producing a silver positive. The second developer also creates dyes that form a positive color image, dark in the shadows and transparent in the highlights. Next, the silver is bleached out, leaving only the dyes of the positive image.

Choosing a Color Film

Film speed influences the appearance of prints and slides. Like black-and-white films, color films are available in a range of ISO ratings. Color films with low ISO ratings are sharper and have more vivid colors and less graininess than high-speed films. Slow films also often have lower contrast, which reduces the undesirable effects of overexposure.

Even within the same speed range, different films produce different color effects. Some films have a warm or red-yellow overall color tint while others look cool or bluish. You can make a comparison by exposing two films under identical conditions. Comparison testing is important with slide film. When slide film is projected on a screen color problems are obvious, so it is important to know how the film will respond to your subject matter.

Magazines like *Popular Photography* regularly feature comparisons between films. Film manufacturers publish technical data sheets for each film. The film's specifications, along with graphs and charts about density and color balance, can help you determine which films are best for your needs. Data sheets can be obtained through the manufacturers and are sometimes found in stores that cater to professional photographers.

Browse the Internet for information and advice. Film manufacturers maintain web sites to promote their films and advise photographers on how to use them. Photographers post messages in on-line discussion groups in which they describe their experiences with films they have tried and will respond to questions from others (see Internet Resources for Photography in the Appendix).

TYPES OF COLOR FILM

Negative film. Produces an image that is the opposite of the original scene in color and density. It can be printed on paper in a darkroom to make a positive or scanned into a computer for editing and printing. It is usually easier to work with negative film if the final medium is a print. Color negative film has a considerable tolerance for under- and overexposure (exposure latitude), and, when scanned, is superior to reversal film for photographs of very contrasty scenes. Color negative film often has "color" in its name (Agfacolor, Fujicolor, Kodacolor).

Reversal film (slide film, transparency film or "chromes"). Reversal film can be projected for viewing, printed on reversal paper in a darkroom, or scanned into a computer for editing and printing. Reversal film requires more precise exposure than negative film because it has less exposure latitude; errors in exposure or color balance may be difficult or impossible to correct in printing. However, reversal film has advantages in cost and convenience over negative film, and images can be viewed directly. Reversal film, especially in large-format sizes, is almost universally preferred by professionals because their images will be reproduced by offset printing presses. Reversal film often has "chrome" in its name (Agfachrome, Ektachrome, Fujichrome).

Professional film. Negative or reversal film with "Professional" in its name means that the film is designed for professionals who often have high standards, especially for accurate color balance. Film ages; its ISO and color balance change during storage. Professional film is shipped with its qualities near their peak and is refrigerated by camera stores to insure that it is in the best condition. Professionals usually buy large quantities of film, preferably all of it from the same manufacturing batch, and shoot test rolls to determine its precise ISO and color balance. Professionals keep film refrigerated until it is used and develop it as soon as possible. Conversely, amateur film may be shipped before it is ready, as the manufacturers anticipate that it will not be used immediately. It often improves after a few months of room-temperature storage. The useful life of unopened film can be extended by refrigeration or freezing. However once film is opened, it is better kept at room temperature and should be exposed and developed promptly.

Films for specialized color balance and exposure times. Each color film is intended for exposure to certain types of light. Ordinary daylight film is color balanced for daylight and electronic flash. Type B tungsten film is balanced for 3,200° Kelvin (or K) studio quartz-halogen lights, although ordinary incandescent light bulbs are acceptable. There are a few films for special situations. Type A film is made for 3,400° K lights. Type L (for long) negative films are designed for long exposures (60 to 120 seconds) under tungsten light.

Color Balance and Film

The color of daylight changes depending on the weather and the time of day. Daylight color film is color balanced for average noon sunlight (above). An hour or two before sunset the light becomes very red or yellow (center). On cloudy days, the color of daylight becomes much bluer (below). Color filters (page 6) can be used to eliminate the bluish color if it is undesirable.

Color film can record colors that your eye does not see when the picture is made. This is because film is manufactured to reproduce color accurately under specific lighting conditions. If the picture is made under the wrong lighting, colors in the photograph become "unbalanced," which means that there is an unwanted color tint (or color cast) over the entire photograph. If a daylight-balanced film is used indoors under incandescent light bulbs, things that are supposed to look white, like a white shirt, will be rendered as reddish. This is because incandescent light bulbs produce more light in the red wavelengths than daylight does.

Color balance is more important with reversal film than with negative film. Because reversal film is viewed directly, any minor color cast will be noticed. The colors in negative films can be corrected in printing, so negative films produce acceptable results under a wider range of lighting. Even so, you get the best colors if the film or digital camera image is shot under correctly balanced lighting or if color correction filters are placed on the lens to correct the color of the light. Video cameras and some digital cameras have circuitry to automatically adjust the color balance to match the color of the light source.

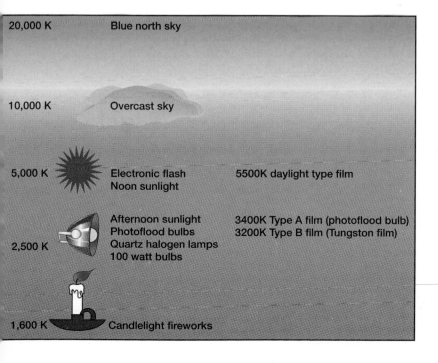

20,000 K	Blue north sky
10,000 K	Overcast sky
5,000 K	Electronic flash / Noon sunlight
	5500K daylight type film
2,500 K	Afternoon sunlight / Photoflood bulbs / Quartz halogen lamps / 100 watt bulbs
	3400K Type A film (photoflood bulb) / 3200K Type B film (Tungston film)
1,600 K	Candlelight fireworks

The color temperature of "white light" is measured on the Kelvin scale. Color temperatures can be used to determine the filter needed to balance the light for a particular film. Warm colors of light have low color temperatures; cool colors of light have high color temperatures.

Different color films are balanced for different color temperatures. Daylight film is balanced for 5,500° Kelvin (or K) light and gives accurate color with midday sunlight or electronic flash. Indoor film, called Type B or tungsten film, is balanced for 3,200° K light and gives excellent color with professional quartz-halogen lights (powerful lights up to 1,000 watts). It will give acceptable, slightly warm color with ordinary incandescent light bulbs, which are 2,500° K to 2,800° K.

Color Balance and Filters
WHEN FILTRATION IS NEEDED

Human vision adapts to lighting situations, but film records colors mechanistically. Our eyes and brains adjust our perceptions so that colors look constant even as we experience a variety of lighting conditions. But if the color balance of the film does not match the color balance of the scene, the film's image will have a noticeable tint or color cast. Images with cool color casts (blue or cyan) or green color casts are objectionable to most audiences. Warm color casts (red or yellow) are more likely to be acceptable. If a scene's color balance causes a color cast, you can remove it by placing a color-correction filter over the camera lens. *For information about how to use specific filters, see page 8.*

Some natural lighting conditions do not match the color balance of any film. Late afternoon sunlight is a familiar one. The atmosphere warms the color of the setting sun. Although noon sunlight matches the color balance of daylight film (5,500° K), afternoon color temperatures may be 3,500° K or even warmer. Cool (bluish) filters like the 80 and 82 series balance this color shift. Some photographers prefer warm colors, so they may not use a filter unless the afternoon reddening is extreme.

Snow scenes present another exceptional condition. The sky in cold weather (or at high altitudes) is often free of haze and thus more blue. Shadows will be filled with intensely blue light—winter sky may have a color temperature of over 20,000° K. Ordinary daylight film will capture too much blue, especially in shadows on snow. A skylight or 1A filter can reduce the blue in shadows without significantly affecting the colors in the rest of the image.

Daylight film in daylight

Tungsten film in daylight

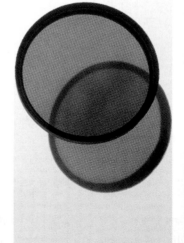

Tungsten film in daylight with 85B filter

Craig Collins

Different types of film record different colors when exposed to the same light. These pictures were all taken in daylight (color temperature 5,500° K). Photographed with daylight film (left) the colors look normal. Photographed with tungsten film designed for 3,200° K lights (center) the scene is bluish. When a color correction 85B filter is used (right) the colors are improved significantly. Since the filter blocks some of the light the exposure must be increased. An 85B filter requires a 2/3 stop increase in exposure.

Fluorescent light has a green cast. Although there are many kinds of fluorescent lights, the type used most widely in homes and offices is similar to daylight but produces over twice as much light in the green part of the spectrum. When you view reversal film images made under fluorescent lights without filters, the green color cast is very apparent (top).

A FL-D (daylight) filter or a magenta filter (approximately CC40M) absorbs some of the green wavelengths (center). It is difficult to recommend exact filter combinations because of differences among films, differences among brands of fluorescent tubes, and color variations caused by voltage fluctuations and the tube's age.

The best way to evaluate color balance is to use a color temperature meter. The color meter shown here measures the amount of red, green, and blue light and computes the Kelvin temperature. It also can calculate the amount of excess green from fluorescent lights. You can use the information to select filters that balance the light.

Daylight film under fluorescent light

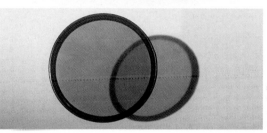

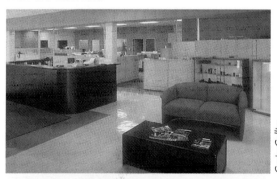

Daylight film under fluorescent light with CC40M filter

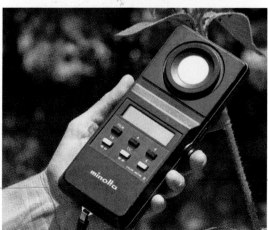

Almost all films fail to produce normal colors under fluorescent lighting. Fluorescent tubes emit extra light in the green portion of the spectrum. Although the light looks nearly normal to the eye, most films record more than twice as much green as normal. Magenta filters are used to compensate for this effect. One negative film, Fuji Reala, is balanced for daylight but reduces the green overexposure in fluorescent light. Thus it is useful for scenes such as offices that are lit by a mixture of fluorescent light and daylight.

Some artificial light sources nearly match specific films. Electronic flash units are almost balanced for daylight film; the light they emit is only a bit bluish. Some photographers correct this by using a mild warming filter. Ordinary light bulbs are warmer than the balance of tungsten film. Tungsten film is balanced for 3,200° K. 100 watt light bulbs emit 2,700° K to 2,500° K light, with low wattage bulbs being even warmer. Many photographers don't bother to correct this imbalance because warm color casts are often acceptable and sometimes preferable.

It is important to balance the light the way you want it when making color slides because the film in the camera is the final product that will be projected for viewing. When reversal film is scanned or printed, some color corrections can be made, but they are limited compared to the corrections that can be made to negative film.

Using Filters

Number or designation	Color or name	Type of film	Physical effect	Practical use	Increase in stops	Filter factor
1A	skylight	daylight	Absorbs ultraviolet rays	Eliminates invisible ultraviolet light that film records as blue. Useful for snow, mountains, marine, aerial scenes, cloudy days, and open shade	none	none
81A	light yellow	daylight	Absorbs ultraviolet and blue rays	Stronger than 1A filter. Use in similar situations and to warm up electronic flash if pictures are consistently too blue.	1/3	1.2
		tungsten		Corrects color balance when tungsten film is used with 3,400° K lights.	1/3	1.2
82A	light blue	daylight	Absorbs red and yellow rays	Reduces warm color cast of early morning or late afternoon light.	1/3	1.2
		Type A		Corrects color balance when Type A film is used with 3,200° K lights.	1/3	1.2
80A or 80B	blue	daylight	Absorbs red and yellow rays	Stronger than 82A. Corrects color balance when daylight film is used with tungsten light. Use 80A with 3,200° K light sources and with ordinary tungsten lights. Use 80B with 3,400° K sources.	2 (80A) 1 2/3 (80B)	4 3
85 or 85B	amber	tungsten or Type A	Absorbs blue rays	Corrects color balance when indoor films are used in daylight. Use 85 with type A film and 85B with tungsten film.	2/3	1.5
FL	fluorescent	daylight or tungsten	Absorbs green and blue rays	Approximate correction for excessive green cast of fluorescent lights. Use FL-D for daylight film, FL-B with tungsten film. Or try a CC40M filter.	1	2
CC	color compensating	any film		Used for precise color correction. Filters come in various densities in each of the six primary colors, red, green, blue, cyan, magenta, and yellow (coded R, G, B, C, M, and Y). Density indicated by numbers—CC10R, CC20R, etc.	varies with density	
PL	polarizer	any film	Absorbs polarized light (light waves traveling in certain planes relative to the filter)	Absorbs reflections from nonmetallic surfaces, such as glass and water, at certain angles. The only filter that darkens blue sky (at certain angles) without changing overall color balance.	1 1/3	2.5
ND	neutral density	any film	Absorbs equal amount of all colors of light	Increases required exposure without affecting color balance. Allows camera to be set to slower shutter speed or wider aperture. Available in densities up to 4 (13 1/3 stops more exposure).	varies with density	

Some manufacturers list the exposure increase needed with filters as a filter factor.

If the filter has a factor of . . .	1	1.2	1.5	2	2.5	3	4	5	6	8	10	12	16
Then increase the exposure (in stops)	0	1/3	2/3	1	1 1/3	1 2/3	2	2 1/3	2 2/3	3	3 1/3	3 2/3	4

If you use two or more filters together, add the number of stops of change (1 stop + 1 stop = 2 stops) or multiply the filter factors (factor of 2 x factor of 2 = factor of 4, equivalent of 2 stops).

A polarizing filter can remove or reduce reflections from glass, water, or any smooth surface except metal. Light waves ordinarily vibrate in all directions at a 90° angle to their direction of travel, but light reflected from smooth, non-metallic surfaces is polarized—its waves vibrate in only one plane. In a polarizing filter microscopic crystals line up like slats in a fence; light whose waves are vibrating parallel to the lined-up crystals pass between them while light whose waves vibrate at other angles is blocked. Since the polarized light is all at the same angle, the filter can be rotated on the camera to block it.

To use a polarizing filter, look through the filter and rotate it until the unwanted reflection is reduced. Then place it over the lens in the same position. (With a single lens reflex or view camera the filter can be adjusted while it is in position over the lens.) Some through-the-lens meters do not correctly measure the light from ordinary polarizing filters; a variant called a circular polarizer is required for a correct reading.

An exposure increase is needed with a filter. A filter reduces the amount of some wavelengths of light, resulting in an overall loss of light intensity. If your camera meters through the lens, it may compensate for this automatically. If you are using a hand-held meter, increase your exposure as shown in the chart at left. Remember that increasing the exposure one stop means changing the shutter speed to double the original time or opening the aperture one stop.

Glass filters attach to the front of the lens and are made in sizes to fit various lens diameters. To find the diameter of your lens, look on the ring engraved around the front of the lens. The filter diameter (in mm) usually follows the symbol Ø.

Gelatin filters are thin sheets of material that can be cut to various sizes. They can be taped onto the front of the lens or placed in a custom filter holder. Handle them by the edges as they are delicate.

A polarizing filter can darken blue skies. Sunlight reflected from particles in the sky is polarized. A polarizing filter is the only filter that will darken skies in a color picture without changing the overall color balance.

The sky-darkening effects of a polarizer are maximized when the camera is pointed at a 90° angle away from the sun. There is no effect when the camera is pointed directly toward the sun or directly away from the sun. Intermediate angles give intermediate effects.

Exposure Latitude
COMPARING COLOR FILMS AND DIGITAL CAMERAS

Accurate exposure is very important with color reversal films and with digital cameras. Reversal films and most digital cameras have very little exposure latitude; that is, they do not tolerate over- or underexposure. Colors in a transparency begin to look too dark with as little as one-half stop underexposure. Because there is little tolerance for overexposure, colors look pale and bleached out. Digital cameras vary in their tolerance to exposure errors, but inexpensive digital cameras produce exposure effects like those of reversal film.

Color negative film has much more exposure latitude than reversal film. You will have a printable negative with as much as one stop underexposure or three stops of overexposure. However, the best results always come from correctly exposed film.

In contrasty lighting, color reversal film and most digital cameras are not able to record the full range of brightness. In scenes with both very bright highlights (like snow or sand) and very dark shadows, the scene's brightness range (the overall contrast) is greater than the exposure range of the film or sensor. If the shadows are correctly exposed the lightest areas will be blank white. If the light areas are well exposed, the shadows will be featureless black. You can compromise and expose for the most important part of the scene. You can also bracket (shoot additional pictures with different exposures). The best solution to contrasty scenes is to use an electronic flash or a large reflector to add light to the shadow areas, thus reducing the scene's contrast.

Lenny Foster

Light from a soft source produces images with less contrast. Low-contrast lighting has a smaller tonal range and thus allows film and digital cameras to easily capture details in both the bright and dark areas. In addition, such lighting is more forgiving of exposure errors than contrasty lighting. Here sunlight is softened by nearby tree branches. Fill-in flash lightens the shadows.

Contact sheet from negatives

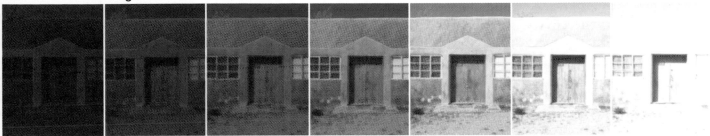

Machine-made prints from negatives above

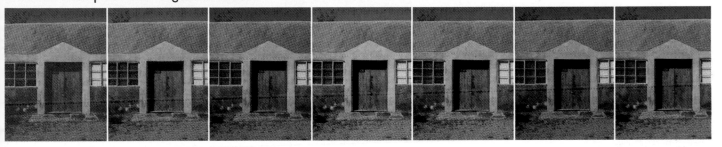

Color negative film has considerable exposure latitude. Your best results will come from a correctly exposed negative, but you will be able to get some sort of image from even a badly overexposed or underexposed negative. Here, exposure varied by one stop for each negative. Top, images from an uncorrected contact sheet made from the negatives. Below, machine-made prints. Each one is corrected for the variations in exposures.

Color slides

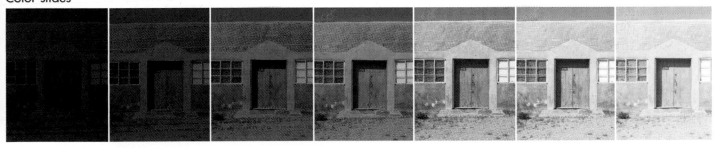

Digital camera images

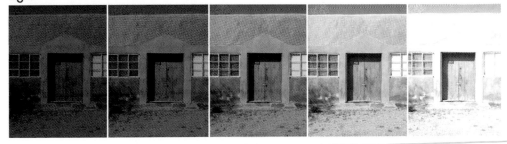

Color transparency film and inexpensive digital cameras have little exposure latitude. Even slight overexposure or underexposure is readily visible, especially in contrasty lighting. Some professional digital cameras capture 36 bits per pixel instead of 24 and are better able to deal with high-contrast scenes than are less expensive, point-and-shoot digital cameras. Exposures varied by one stop for each of these frames; top, color transparency film; bottom, a midpriced digital camera.

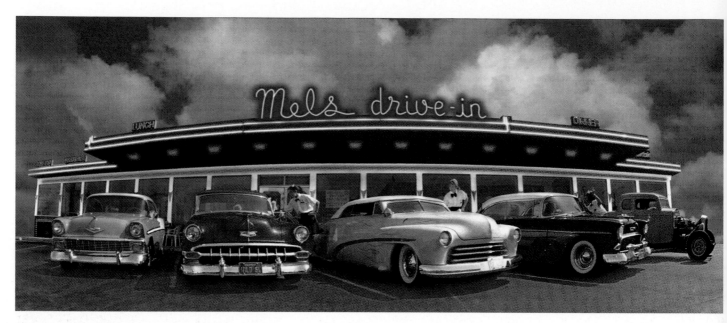

ANNABELLE BREAKEY Advertisement for Mel's Diner, San Francisco, California.

2

DIGITAL IMAGING

Before computers, the history of photography was one of gradual improvement. The slow evolution of film, cameras, darkroom materials, and printing press technologies produced improvements in image quality, ease of use, reliability, and consistency in mass reproduction. Then in the 1980s, computers suddenly began to revolutionize photography. Now, even casual snapshooters can take advantage of digital technology.

There are many advantages to digital imaging. Digitizing an image (converting it to a numerical form that a computer can manipulate) lets you make changes that are often difficult and tedious to do by conventional means. You can retouch, dodge, burn, crop, color, combine, and alter photographs in dozens of different ways without ever stepping into a darkroom. Images are stored as electronic data, so a database can be created within which many images can be stored, indexed, searched for, and quickly retrieved. Unlike film and prints, digital images can be duplicated without any loss of quality; a file that has been copied repeatedly can be identical to the original. You can use ordinary telephone lines to send a digital image around the world, in some cases faster than you can carry a print to the office next door.

Traditional darkrooms are often inaccessible to people with disabilities. Exposure to darkroom chemicals, especially those used in color processing, can be harmful to sensitive people; chronic chemical exposure can result in long-term health effects even to people who experience no immediate adverse effects.

Some costs accompany all the advantages. There is a time investment in learning how to use equipment and software skillfully. There is also a financial investment: The better the quality you want, the more that equipment, software, or services, such as a print made at a service center, may cost. However, most users feel the investment is worthwhile because digital imaging allows you to realize more of what you see and what you can imagine.

This chapter introduces some basic concepts in digital imaging. You'll understand how pictures are turned into pixels and how pixels contain information about color. You'll understand the terms that describe technical aspects of images: resolution, dots per inch (dpi), pixels per inch (ppi), bit depth, and color modes. Technical issues aren't the only important ones; you'll also learn about the ethical and legal issues raised by the computer's ability to copy and alter artwork created by others.

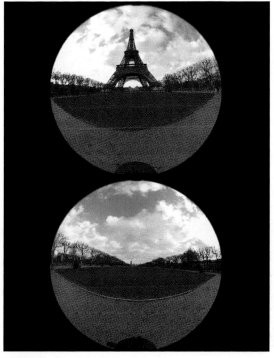

iPIX Corporation

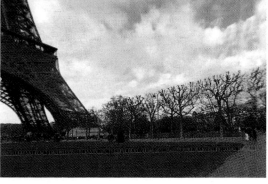

iPIX Corporation

A picture that could not exist without a computer. Fisheye lenses make photographs of an entire 180° hemisphere. Two fisheye images were exposed in opposite directions to make the two round images shown here. They were joined by using patented iPIX software to create a complete 360° immersive image of the scene. The image can be viewed on a computer monitor, where it appears without the distortions typical of a fisheye lens. Below the fisheye images, an image captured from a computer screen shows an undistorted view of one part of the panorama. Computer users can manipulate the image by scrolling right and left or up and down, to see the entire 360° panorama.

Digital Imaging: An Overview

To understand digital imaging, compare it to conventional photography. Think of the steps you take in conventional photography: exposure, development, and printing.

With digital imaging, instead of ordinary exposure and development . . .

- You *capture* an image by recording it with a digital camera or by using a scanner to read the image into the computer from a conventional negative, slide, or print. In either case, the image is digitized, that is, recorded in a numerical form that is usable by the computer.

- You can then *display* the image on the computer monitor while you

- *Edit* the image, using software commands to change its color and tones.

- You *store* the electronic file that contains your image inside your computer or on a removable disk or CD-ROM.

- You can *transmit* it electronically to another location, or

- *Output* it to a printer that reproduces it on paper or film.

EQUIPMENT AND MATERIALS YOU'LL NEED

You don't need to own all, or even any, of these items yourself. Many schools provide access to computers, scanners, printers, and other equipment. Computer service bureaus (often in shops that do copying and offset printing) rent time on computers, scan and print images, and generally offer help on how to use their services. See the Appendix for more about your hardware choices.

CAPTURING

Digital camera — does not use film. It electronically records the image in digital form.

Scanner — reads and converts a conventional negative, slide, or print into digital form.

Kodak Photo CD — is an easy means of acquiring scanned images. You take your negatives or slides to a photo store, lab, or computer service bureau to have them scanned onto a Photo CD, something like a music CD. You need a suitable CD-ROM (Compact Disc Read-Only Memory) drive to transfer the pictures from the Photo CD to your computer.

COMPUTING

Computer — drives the monitor, printer, or other devices to which it is attached. The more powerful the computer, the faster it operates.

DISPLAYING

Computer monitor — displays the image you are working on and shows various software tools and other options.

EDITING

Image-editing software (such as Adobe Photoshop or Corel PhotoPaint) — provides many editing commands that change the image, either subtly or drastically.

STORING AND TRANSMITTING

Hard disk (or hard drive) — stores image files within the computer. A picture file can occupy a large amount of hard disk space, so generally only a limited number of pictures can be stored.

Removable storage media (such as a Zip drive or other removable cartridge disk drive) — let you expand your storage or let you take a file to another location, for example, to be printed.

Modem — sends files over phone lines and is often used by photojournalists and others who need to transmit pictures from a distance in a hurry. Digitally encoded images are also transmitted worldwide on the Internet.

OUTPUTING

Printer — transfers the image to paper. Print quality varies widely from high-quality and expensive dye-sublimation prints to less-expensive prints that are more like ordinary office photocopies.

Film recorder — prints the image onto film as a positive transparency or a negative.

CD or DVD recorder — stores the image on a CD or DVD, so other computers can display it.

HTML software — places the image in a Web page that can be viewed over the Internet.

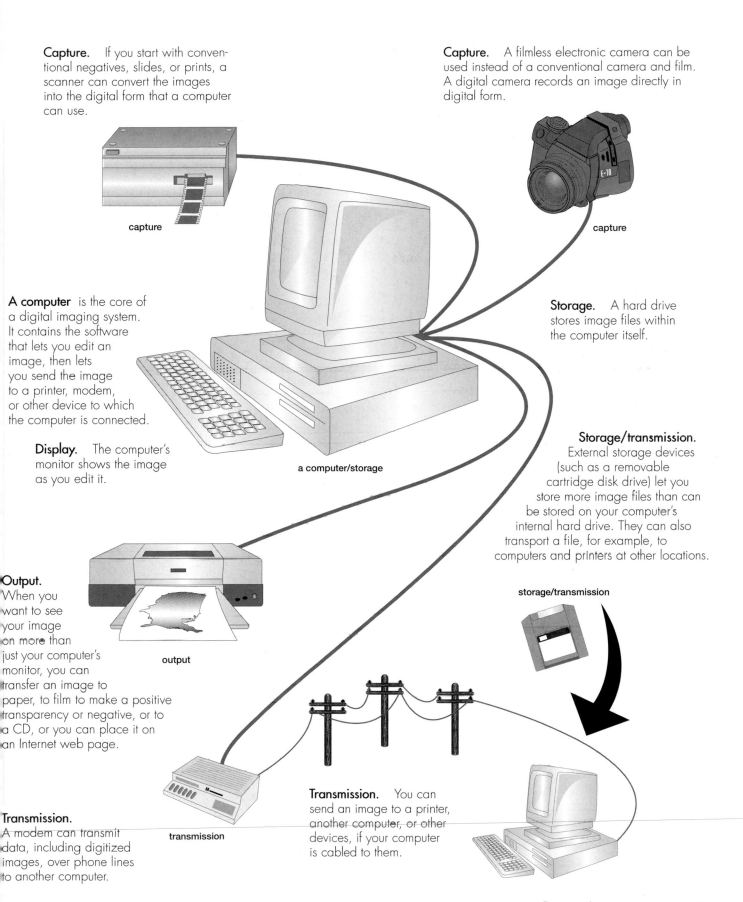

Capture. If you start with conventional negatives, slides, or prints, a scanner can convert the images into the digital form that a computer can use.

capture

Capture. A filmless electronic camera can be used instead of a conventional camera and film. A digital camera records an image directly in digital form.

capture

A computer is the core of a digital imaging system. It contains the software that lets you edit an image, then lets you send the image to a printer, modem, or other device to which the computer is connected.

Storage. A hard drive stores image files within the computer itself.

Display. The computer's monitor shows the image as you edit it.

a computer/storage

Storage/transmission. External storage devices (such as a removable cartridge disk drive) let you store more image files than can be stored on your computer's internal hard drive. They can also transport a file, for example, to computers and printers at other locations.

storage/transmission

Output. When you want to see your image on more than just your computer's monitor, you can transfer an image to paper, to film to make a positive transparency or negative, or to a CD, or you can place it on an Internet web page.

output

Transmission. A modem can transmit data, including digitized images, over phone lines to another computer.

transmission

Transmission. You can send an image to a printer, another computer, or other devices, if your computer is cabled to them.

Pictures into Pixels

A picture that you take with film in an ordinary camera is in analog form. Analog means that the image's tones and colors are on a continuously variable (analog) scale, like the volume on a stereo, which changes in smooth gradations from soft to loud. The image on a film negative has a smooth, continuous scale of tones, with unbroken gradations from light to dark.

For computer use, the picture is converted to a digital form, called a bitmap image or raster image. The image is sampled at a series of locations, with each sample recorded as a single, solid-toned **pixel** (short for picture element). The pixels that make up the image are arranged in a grid, like the squares on a sheet of graph paper. In the finished image, the pixels are so small that you don't see them individually; instead you see a smooth gradation of tones. You can see pixels if you enlarge an image enough on your computer (see illustrations, this page).

The original analog image is converted into digital form by assigning each pixel a set of numbers to designate its position, brightness, and color. Once the image is digitized, you can use editing software, like Adobe Photoshop, to select and change any group of pixels in order to add or change color, to lighten or darken, and so on. The computer does this by changing the numbers assigned to each pixel.

To put an image into digital form, the image is divided into a grid containing many tiny segments called pixels. The location, brightness, and color of each pixel are recorded as a series of numbers that are then saved by the computer for later use.

To see pixels on your computer's monitor, select a part of the image and enlarge it. If you are using Adobe Photoshop, for example:

- Open a picture file.
- Select the Zoom tool (shown in the toolbox at right as a magnifying glass) by clicking on it.
- Place the magnifying glass on the image. Click on the image repeatedly to zoom the image to greater degrees of enlargement.
- To reverse the zooming and return the image to the original size, click on the image repeatedly while holding down the keyboard's Option or Alt key.

Each square is a pixel. Notice that each contains a solid tone; the color or brightness varies from pixel to pixel, but not within a pixel.

The greater the bit depth, the more colors or tones are possible in a picture.

0	0	0
0	1	0
0	0	0

1 bit per pixel produces 2 tones, black and white. Left, the image can have only two tones, black and white. Center, an enlargement of nine of the pixels. Right, how the computer represents the pixels with numbers.

0	95	191
31	127	223
63	159	255

An 8-bit pixel has 256 black, white, and gray tones available. Left, this is enough for an excellent black-and-white rendition. Center, an enlargement of nine pixels. An 8-bit pixel can also produce any of 256 colors, enough for a limited color rendition. Right, the same tones are represented by numbers: 0 (black), from 31 to 223 (various shades of gray), to 255 (white).

| 255 | 0 | 73 | 0 |
| 0 | 255 | 230 | 0 |
0	255	165	0
0	255	140	127
255	0	63	127
0	255	184	127
---	---	---	---
0	255	255	255
0	255	153	255
255	0	51	255

A 24-bit pixel has more than 16 million colors available. Left, it can produce an image comparable to a conventional color film photograph. Center, an enlargement of twelve pixels. Right, here the colors are produced by mixing the primary colors red, green, and blue. Each of the three colors has eight of the pixel's 24 bits, or 256 possible tones. 255 indicates the maximum amount of a color; 0 indicates none of the color is present.

The bit depth, or number of bits each pixel contains, determines the color and tones in an image. Computers record information in binary form, using combinations of the digits 1 and 0 (zero) to form all other numbers. A bit is the smallest unit of information, consisting of either a 1 or a 0. A pixel may contain as little as one bit, either a 1 or a 0, or it may contain 24 bits or even more.

The greater the bit depth, the smoother the gradation from one pixel to another, because each pixel will be able to render a greater selection of possible colors and tones. A picture composed of 1-bit pixels (consisting of either a 1 or a 0) will have only black or white pixels (see illustration this page, top).

An 8-bit pixel is composed of eight bits in a row. There are 256 ways to arrange eight 0s or 1s, starting with 00000000 (zero) and ending with 11111111 (255), so an 8-bit pixel can represent 256 colors, which are enough for only a mediocre color reproduction. However, this 8-bit pixel will reproduce a very good black-and-white image containing 256 different black, gray, and white tones (see illustration this page, center).

To depict a picture with realistic colors and tonality, a 24-bit pixel is needed. A pixel containing 24 bits can represent any one of over 16 million colors (see illustration this page, bottom).

Increasing the bit depth has a price. An image composed of 24-bit pixels takes up three times as much disk storage as an image composed of 8-bit pixels. It also requires three times as much RAM (random-access memory) to display the picture, and editing and saving take three times as long. However, because quality increases as bit depth increases, increases to a 48-bit depth are likely in future editing software.

Picture "Size"

PPI, DPI, AND OTHER IMAGE MEASUREMENTS

How big is your picture? You'll need to know how pixel data is measured as you prepare to scan an image, print it, or perform other operations. See also Bit Depth, page 17.

Physical size is a familiar place to start. It is the width and height of the image measured usually in inches or sometimes in other units, like centimeters. For example, 8 inches wide by 10 inches high.

Pixel dimensions (resolution) are the number of pixels along the height and width of an image. The number of these pixels is determined by the settings of your scanner or digital camera at the time the image is digitized. For example, a scanned 8 x 10-inch print might have pixel dimensions of 2,400 pixels wide, 3,000 pixels high, or simply 2,400 x 3,000. Generally, the more pixels you have, the better the quality of the image (see illustrations this page).

Pixels per inch (ppi, the apparent sharpness of an image) is calculated when an image is printed or is displayed on a monitor. Assuming that the number of pixels remains constant, the pixels per inch—and the sharpness—will change as the size of the printed or displayed image increases or decreases. For example, as you increase your print size, the same total number of pixels spread out to fill a bigger space. Each pixel has to increase in size, which makes the image appear less sharp than a smaller print of the same image (see illustrations opposite).

Dots per inch (dpi) is used for several measures. As an indication of the detail a printer can produce, it is the number of dots of ink produced by a printer as it prints an image. In general, the more dots per inch, the clearer and more detailed the image. However, there are exceptions, depending on the type of printer (see halftone devices, page 37).

An image with very few pixels. A 35mm slide (1½ inches x 1 inch) scanned at only 20 samples per inch (20 dpi) results in an image of 30 x 20 pixels. Notice how little detail the image has. The image's file size would be only 1,800 bytes because there are only 600 pixels and each pixel uses 3 bytes (24 bits). The calculation is 30 x 20 pixels x 3 bytes per pixel = 1,800 bytes.

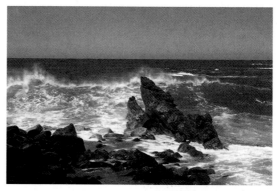

An image with many pixels. The same slide was scanned at 300 samples per inch (300 dpi), which created an image of 135,000 pixels (450 x 300). Notice how much more sharpness it has compared to the 20-dpi image. The image's file size would be 405,000 bytes (approximately 400 kilobytes). The calculation is 450 x 300 pixels x 3 bytes per pixel = 405,000 bytes).

PROJECT

RESOLUTION, FILE SIZE, AND SHARPNESS

What you need A 3 x 5 to 5 x 7 photograph, with sharp details, and a scanner.

Procedure Scan the picture twice, once at 50 samples per inch (50 dpi) and once at 200 samples per inch (200 dpi). Save both files. Note the two file sizes. Examine the two images side-by-side on the monitor. To help you compare them at equal size, zoom the 50 dpi image to 400 percent but view the 200 dpi image at 100 percent.

How did you do? You should have found that the image scanned at 200 dpi has a file size about 16 times larger than that of the image scanned at 50 dpi. The image scanned at 200 dpi should look significantly sharper than the other. The reason that the 200-dpi image is sharper than the 50-dpi image is that it has 16 times more pixels.

Bonnie Kamin

Print size affects sharpness. If the number of pixels remains constant, increasing the size decreases the sharpness. Here, the same image file was printed at three different sizes. As the image increases in physical size, the size of each pixel also increases, making the image appear less sharp.

Note that in the largest print, the pixels have become so large that they are individually visible. This is similar to what happens when you make a very large darkroom print from a small negative, for example, a 20 x 24 print from a portion of a 35mm negative. The grain in the film is magnified so much that it becomes visible.

Dots per inch also measures the number of pixels per inch that a monitor can display. Additionally, dots per inch refers to a scanner setting, preferably called *samples per inch,* the number of times per inch a scanner "samples" an image to convert it to a grid of pixels.

File size measures the amount of disk space occupied by an image (see chart this page). It is affected by pixel dimensions and bit depth, plus other factors such as file format and how much the image is compressed for storage (see page 39).

The bigger the file size (usually) the better the picture quality, but unfortunately you can get too much of a good thing. As the file size increases, the computer has to process and store more data about the picture. If the file is very large, this can cause problems by greatly increasing the time the computer takes to execute each command or by increasing to an unwieldy size the amount of computer storage space needed. Tradeoffs may have to be made between the quality desired and the file size that can be conveniently handled by your computer.

How you set up a file depends on the final output you want. For example, the number of pixels per inch for a scan is dependent upon how big you want the final print to be. At a school, your instructor can tell you how to specify the pixels per inch and other file characteristics when you are setting up an image file. If you are using a service bureau to scan or print your pictures, you can ask them how they suggest you set up the file. See also your image-editing software manual. More information follows in this book on how to set up and adjust your image files.

FILE SIZE

File size measures the amount of disk space or RAM occupied by an image, usually listed as the number of bytes the file contains.

bit	The smallest unit of digital information
byte	8 bits
kilobyte (KB)	1,000 bytes
megabyte (MB)	1,000,000 bytes
gigabyte (GB)	1,000,000,000 bytes

(The numbers are rounded off. A binary kilobyte, for example, actually contains 1,024 bytes.)

Modes and Color Spaces
How computers work with color

Computers create colors in several ways. When you scan an image or capture it with a digital camera, a set of numbers is created to represent the colors of each pixel. However, there is no standard way to assign numbers because there are many systems for numbering colors, including some that were devised before the age of computers. Scientists call these systems **color spaces.** A color space numerically describes all the colors that can be created by a device such as a camera or a printer. You do not need to understand color spaces, but you need to be aware that color spaces differ because some contain more colors than others—making it impossible to exactly translate colors from one color space to another. If you understand that your scanner and camera use a color space that contains more colors than your printer, you'll be able to make adjustments that result in better prints.

RGB color for capture and display. Scanners and digital cameras use the RGB color space. In RGB, each pixel is given a separate number for each of the three primary colors, red, green, and blue. (To see an RGB pixel, see the illustration at the bottom of page 17). Scanners and cameras have red, green, and blue filters placed over the sensors that measure the light intensity. Scanners and cameras thus are like color film, where each of the three light-sensitive layers is sensitive to only one RGB color. RGB mode is usually 24-bit RGB; each color is assigned 8 of the 24 bits. Some cameras and scanners may use 12 or more bits per color to achieve better quality. Adobe Photoshop software can edit 48-bit RGB images where each color is assigned 16 of the 48 bits.

Computer monitors are also RGB devices. A monitor's screen creates color when its red, green, and blue phosphors glow after they have been struck by the tube's electron beams.

ALIDA FISH Walking with Pygmalion #8

Alida Fish has created a series of images that make us reflect on Americans' obsession with "the perfect body." She blended photographs of the bodies of ordinary Americans into photographs of statues from classical antiquity. By substituting realism for perfection in these classic sculptures, the composite images surprise us and upset our expectations about classical art. The images remind us that our fascination with bodily perfection has its origins among the Greek and Roman founders of western civilization more than 2,000 years ago.

To achieve the effects in this image, Fish scanned the two images in Grayscale mode, which gives 256 levels of gray from black to white but no colors. She blended the images using Photoshop (see Layers, page 75). By making the top layer solid in some places and semitransparent or wholly transparent in other places she made the two images blend seamlessly.

The finished digital image was printed onto black-and-white film (see film recorders, page 103) and printed in an ordinary darkroom. To achieve the color effects, Fish permitted colored stains to form while the image was developing. She achieved the stains by prolonging the development time. Stains were enhanced when she removed the print from the developer and sprayed it with a variety of unusual photographic chemicals. The result is a one-of-a-kind print.

Note: the developing procedures used by the artist may produce harmful gasses. Exhaust fans are absolutely necessary to remove the gasses and to protect the health of the darkroom worker.

RGB cannot create photographs on paper, however, because intermediate colors like cyan, magenta, and yellow cannot be created by mixing RGB inks. When red and green phosphors mix on a computer monitor, yellow is the result. This is because RGB is an additive color space (see page 2) where color mixtures are created when light of the three primary colors is added to a dark background, like a monitor screen. However, when red and green inks mix on paper the result is black. This is because ink on paper is a subtractive color space: the background (paper) is white, and inks subtract colors from white. Red ink subtracts green and blue, while green ink subtracts red and blue. Working together they subtract red, green, and blue; the paper is black because no light is reflected.

CMYK color for prints on paper. Since a subtractive system of colors must be used in printing, the CMYK color space is used. CMYK is the three subtractive primary colors—cyan, magenta, and yellow—plus black, whose function is explained below. Unlike RGB inks, cyan, magenta, and yellow inks create intermediate colors. For example, yellow ink plus magenta ink creates red. The yellow ink subtracts blue, while the magenta ink subtracts green. Both inks reflect red, so only red appears on the paper.

Why is black ink used? Black (the K in CMYK) is necessary because the CMY inks used in printing are not color perfect. When all three are mixed together they create brown instead of black. Black ink is added to improve black and near-black tones. Adding a fourth color

makes CMYK a 32-bit color space because each of the four colors uses 8 bits.

Modes determine the color space of an image. Imaging software calls a color space like CMYK a mode. In Adobe Photoshop, modes are accessed with the Image > Modes command. When a new mode is selected, the current image is converted from its original mode into the selected mode. There are several modes beside RGB and CMYK. **Grayscale** mode is often used in black-and-white photography; it's a colorless mode, measuring only brightness. It creates 8-bit images that have 256 levels of gray. **Indexed color** is a mode used to create color images that use only 256 colors (8-bits) or less. It is of limited use for most photographic images but is ideal for creating graphics for the Internet.

Editing the image: There are possible conflicts between RGB and CMYK modes. When an image is printed on paper, problems can occur. The way the image looks on an RGB monitor rarely matches the print created with CMYK inks. The colors created by inks and phosphors never quite match. Photographers usually edit images in RGB mode because most home, school, and small-business printers, such as inkjets and color laser printers, do a good job of translating RGB colors into CMYK colors. However, when preparing images for publication, photographers usually prefer the software's CMYK mode. When CMYK mode is selected, the software reduces the range of colors the monitor can display in order to mimic the colors that the inks can produce. The problem of getting the print to match the monitor will be discussed in chapters 4 and 6.

Digital Imaging, Changing Ethics, and the Law

Is it possible? vs. Is it right?

Technology is changing artists' attitudes about the rightness of copying, altering, and using other artists' original work. Electronic mass media have created a new culture in which individual images seem like mere raw material. This is an inevitable outcome of the increasing number of images to which we are exposed. By watching television for a single day an American sees more images than George Washington saw in his entire life. It's as though we have been dropped into a newly created visual ocean.

Often, artists create new art out of the changes in the society in which they live. New movements in art have come about as a thoughtful response to this deluge of images. Artists use their own work to explore and comment on the way that visual images have lost their value as unique expressions and become unwanted, throwaway commodities. Inevitably, this requires making realistic or even exact copies of the very images they are commenting on. Digital imaging has made such copying easy. Some artists have concluded that the image glut has made originality impossible. Their work does not even attempt to include original visual elements; they use copied images as icons to communicate their ideas about the new conditions of art and society. Recycling previous art to create new art is called appropriation.

Appropriation is a hotly debated topic. At one end of the spectrum of appropriation is the ancient and innocent practice of copying art as part of an art education. A painting student might copy a Rembrandt painting in order to learn how to render shadows. At the other end is willful, illegal copying for profit. In the middle is a growing gray area created by the ability of digital tools to alter a copied image beyond recognition—with very little work on the artist's part. Society has not yet formulated and legislated satisfactory standards that apply to digital

copying. We are facing the digital future with old, perhaps obsolete, legal standards.

Copyright laws were created shortly after America was founded. Their purpose was to protect the livelihood of creative people whose writings and musical scores were being illegally reprinted by unscrupulous profiteers. Visual arts were eventually included. However, the laws recognized that some kinds of copying are acceptable "fair use," such as quotations in scholarly works or in works of criticism. Some amount of "quoting" of visual works was also found to be "fair use."

Increasing uncertainties about the limits of "fair use" cause legal disputes. In making decisions about fair use, courts traditionally considered whether the copying was done for educational and artistic purposes or purely for profit. They weighed the amount of copying

Traditionally, photojournalists have been proud that their work is not manipulated. But digital imaging offers powerful temptations. Suppose you photograph a group of people. One image from the series is clearly the best, except that one man in the group blinked his eyes. Could you copy his open eyes from another image and paste them over his blinking eyes? Absolutely—if you are a commercial photographer hired by the man who blinked. But if you are a journalist, your employer might consider it grounds for discipline.

Many news publications have adopted policies prohibiting any digital editing that goes beyond traditional darkroom practices. Acceptable editing is limited to cropping, overall color correction, dodging, and burning.

and if income was lost by the originator whose work was copied. Traditionally, artist-copyists had few legal problems because their copying was usually not highly profitable. Further, one-of-a-kind copying is time consuming and rarely caused financial loss to the artist whose work was copied. But now digital imaging has made mass copying very easy, and some artists work entirely with appropriated images. Digital imaging has also helped reduce the distinctions between commercial art and fine art. Thus there is an increasing chance of a collision between the new ethics of artists and the rights of the creators of the appropriated art.

MONICA CHAU Barracks

Historic images are often the subject of "fair use" appropriation. In a series of images, Monica Chau combined vintage photographs of the forced relocation of Japanese-American citizens during World War II with recent images of the Manzanar, California, relocation camp that housed thousands of them. Because little remains of the desert camp but a historical monument and a few decaying buildings, Chau superimposed a 1944 photograph of camp barracks onto a photograph she took at the camp site.

Although the 1944 image is still copyrighted, most would agree that her use of the image is acceptable because it falls under the "fair use" doctrine. It is unlikely that she will profit significantly from the images; her images are clearly artistic and have educational purposes. Specifically, she intends the series to foster a discussion about an historical incident in which America fell short of its ideals and inflicted harm on some of its loyal citizens.

NASA/JPL

3

IMAGE CAPTURE AND STORAGE

Digital imaging expands the possibilities of your photography. When you use digital cameras or scanners you can enjoy the speed and convenience of instant image capture or the high quality of film-based photography.

With a digital camera, you don't need to develop film before you can see and use the images. The images can be seen directly on a playback screen built into the camera or on a computer monitor. The images are usable as soon as you shoot them, which is important if you are a news photographer working on a far-away story. You can view and edit your pictures immediately, then transmit them to your editor by modem over a telephone line.

With film, you can have the best of both worlds. Film can record much more information than any but the most expensive digital studio cameras. Sharpness, color, and tonal range are much better when you start with film. When your developed film is scanned into a computer, image-editing software can raise the quality of your images beyond anything you could do in the finest darkroom.

The first step is to capture the image in digital form. To get an image into the digital form that a computer can use, you must capture it with a scanner or an electronic camera. If you start with a negative, a transparency, or a print, you capture the image by putting the image in a scanner attached to the computer. If you use an electronic camera you can send the image directly to the computer through a cable or through removable disk drives or memory cards that you take from the camera and put into the computer.

Opposite **JET PROPULSION LABORATORY** The planet Mars, July 1965.
Among the first digitally processed photographs seen by the public were video images of Mars radioed to Earth by the NASA spacecraft Mariner 4. The primitive, 7-bit, black-and-white images of the cratered surface of the planet were historic; not only were they a technical achievement, they ended nearly a century of debate over the possibility that Mars was covered by a network of canals dug by an advanced civilization.

Electronic Cameras
ANALOG AND DIGITAL CAMERAS

Electronic cameras don't use film. In an electronic camera, a silicon chip captures the light from the camera's lens. In hand-held cameras, the chip contains hundreds of thousands of microscopic sensors (pixels) arranged in a regular grid of rows and columns. Each of these sensors is capable of recording the brightness of the light that falls on it. The light falling on each sensor is converted into a continuous or analog electronic signal. An analog signal is one in which the signal's intensity can vary continuously (smoothly) from zero to the maximum intensity. As a result, light and dark tones in the image are translated into variations of the signal's intensity.

Traditional video cameras and camcorders store images in analog form. In these cameras, the analog signals from the chip are amplified and stored as analog signals on tape. Coincidentally, photographic film is also an analog medium; the amount of silver or dye in developed film depends on the amount of light to which the film was exposed. All images stored in analog form have a serious drawback. Whenever the image is duplicated the copy is not identical to the original. The image loses sharpness, and the tones and colors are not as accurate.

Most electronic cameras store their images in digital form, because digitally stored information can usually be copied with no loss of quality. In a digital camera, the analog signals from the sensors are immediately converted into digital numbers that represent the color and brightness of the light. When a computer opens the image, these numbers become the brightness and color values of the pixels that make up the image.

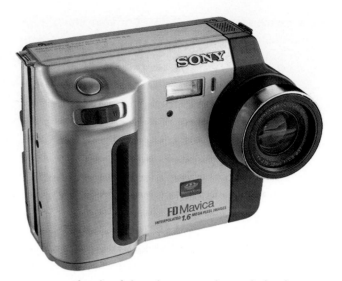

The Sony Mavica is a family of digital cameras that includes the Mavica FD92, an inexpensive and easy-to-use model. The FD92 captures images with a resolution of up to 1,472 x 1,104 pixels. An LCD screen (page 28) serves as a viewfinder and playback device. JPEG-compressed images (page 39) are stored on a 3.5" diskette, which can be read by almost any computer.

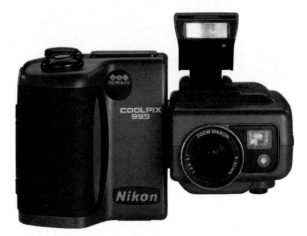

The Nikon Coolpix 995 is a powerful, midpriced digital camera, suitable for some professional applications. It has a built-in zoom lens with impressive wide-angle and telephoto auxiliary lens attachments. Images can be compressed or left uncompressed if the highest image quality is desired. It provides many features of 35mm cameras, such as manual exposure and manual focus.

The Coolpix family of cameras is innovative in offering many digital image-editing features, such as contrast adjustment (page 48). They also have the ability to automatically edit a series of captures and keep only the sharpest one.

Digital cameras provide more depth of field than 35mm cameras. Top, a close-up photograph taken with a 35mm camera and a wide-angle lens. The lens is set to f11 to increase depth of field. Center, a photograph taken with a Sony Digital Mavica camera with the zoom lens set to 5.2mm (a focal length that produces a perspective similar to that of the 35mm camera). The Mavica lens is set to f2. Bottom, another photograph taken with the Mavica, but with the lens set to f11 for greater depth of field. Note how the Mavica's image at f2 has approximately as much depth of field as the 35mm camera's f11 image and how the Mavica's f11 image has even more depth of field.

Hand-held and studio digital cameras. Hand-held digital cameras are also known as **one-shot** cameras because, like 35mm cameras, they capture images instantaneously (page 28). Studio **tricolor** cameras take a series of three exposures, one for each color. Studio **scanning** cameras (page 31) capture images gradually, like a flatbed scanner captures a print.

Digital cameras require computer-type memory or disks to store images. Many cameras have built-in memory and require plug-in cables to transfer the image to a computer or printer. Others accept tiny removable memory cards. If a computer has a compatible memory card reader, it can download the images from the card. Small removable hard-disk cartridges, containing hundreds of megabytes, are built into some cameras; other cameras accept floppy disks. Large-format studio cameras are like scanners; they have no memory of their own and must be connected to a computer. The computer operates the camera's controls and stores the images.

Electronic Cameras

While nearly all 35mm SLR film cameras can produce very sharp images, the resolution (image sharpness) of electronic cameras varies widely. The sharpness of a digital camera's image is limited by the number of sensors (pixels) on the image-capturing chip. When choosing a digital camera you must consider how the images will be presented, otherwise you may choose a camera that can't take sharp-enough images. If your images will be presented on the Internet or on a CD-ROM, a camera with a resolution of only 640 x 480 pixels may be quite satisfactory. But if the images will be printed at 5 x 7 inches and must look sharp, a higher resolution camera is necessary, one that has a resolution of at least 1,280 x 1,024 pixels. If you need sharp 8 x 10-inch prints, it's better to shoot film and scan the images at a resolution of at least 3,000 x 2,000 pixels, or use at least a six-megapixel digital camera (six megapixels is 3,000 x 2,000 pixels).

Good exposure is important. Because inexpensive digital cameras create images that are very sensitive to over- and underexposure (see page 10), exposures must be accurate. Exposure compensation controls, which give deliberate over- and underexposure, are useful because most one-shot digital cameras are fully automatic and have no manual f-stops and shutter speeds. Most cameras have LCD viewfinders that let you see the captured image; this is helpful because you can evaluate the exposure quality and reshoot the picture if necessary (see opposite).

Lenses and shutters: restricted choices. Most one-shot digital cameras don't have interchangeable lenses. Some, however, offer non-interchangeable but high-quality zoom lenses.

All but the most expensive digital cameras have a restricted range of shutter speeds and generally can't take good-quality time exposures of night scenes. Only the most expensive digital cameras, such as those in the Kodak DCS series, offer all the features of 35mm SLR cameras.

Camcorders as electronic still cameras. Camcorders (video cameras with built-in videotape recorders) usually are a poor choice for making still images. Even the best digital camcorders only equal the image quality of inexpensive digital still cameras. Of course, the ability of a camcorder to capture continuous action makes it preferable for situations where a still camera may fail to capture an important moment.

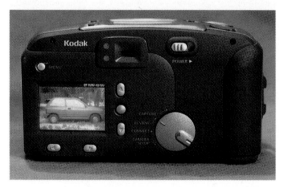

A liquid crystal diode (LCD) panel on the back of a digital camera allows a photographer to review images after they have been taken; the photographer can use it to decide which images to save and which to erase from the camera's memory. LCDs can be used as viewfinders, allowing the photographer to preview cropping, exposure, and color balance. A limitation of LCD panels is that they have fewer pixels than the captured image, so sharpness cannot be previewed reliably, unless the LCD lets you zoom into (enlarge) the image.

Digital camera resolution. Digital cameras with sensors containing only 640 x 480 pixels do not produce sharp prints. At print sizes over 3 x 5 inches the individual pixels are visible.

These images are actual-size sections from 8 x 10 inch prints. Left, an image made with a 640 x 480-pixel digital camera. Note how soft the image is. Center, an image made with a digital camera that captures about four times as many pixels, 1,280 x 1,024. Even this image is not as sharp as one made from 35mm film, scanned at a resolution of 3,072 x 2,048 (right).

640 x 480
digital camera

1280 x 1024
digital camera

35mm camera
scanned at 3072 x 2048

Electronic Cameras
Downloading images from one-shot cameras

Downloading images from a one-shot digital camera is easier than scanning film or prints because the images are already in digital form. All you need to do is move the image files from the camera's storage device onto the computer's hard disk.

Some cameras download image files to the computer with a cable. Software will come with the camera, and you'll need to install it in the computer before connecting the two. Then you should follow the downloading instructions in the camera's manual. Often the software makes the computer think that the camera is an external disk drive. This is an advantage, because you will be able to preview the images while they are in still in the camera. You can then download only those images you wish to keep, saving time and hard-disk space.

If the camera does not use a cable to connect with the computer, it may store its image files on a removable waferlike memory card. Types of cards include PCMCIA cards, CompactFlash cards, and SmartMedia cards. To transfer the image files, you remove the card from the camera and insert it into a compatible card reader attached to your computer.

Some cameras store their image files on built-in removable disks, so you can transfer images by removing the disk and placing it in a disk drive in the computer. Although a few cameras use the standard 3.5" diskettes that all computers can read, most require the attachment of a specialized disk drive to the computer. Once a disk or memory card is inserted in the reading device, the computer treats it like regular disk, so you can drag the files you want from the disk or card into the computer's hard disk.

San Francisco photo-illustrator Annabelle Breakey uses a sophisticated Leaf one-shot digital attachment on the back of her Hassleblad camera. Because the digital camera back has no memory it cannot store images. As each image is taken it is downloaded by cable to a computer. Breakey and her client evaluate the image on the computer monitor and immediately decide if it is satisfactory or if she needs to make another exposure.

The Leaf digital back contains a 2,048 x 2,048 pixel CCD chip that produces images with tonal and color quality equivalent to those made with film.

Some cameras let you send your images directly to a printer. Once you attach a cable to the camera, the printer will print a selected image. This is useful if you are in a hurry, but camera images that haven't been enhanced by image-editing software usually don't have enough quality (especially color quality) for most display purposes.

The highest quality images are made with studio-type view cameras. Both traditional film holders and digital backs can be inserted into a view camera. Digital backs for 4 x 5 view cameras can capture images with up to 8,000 x 10,000 pixels. The resulting images contain as many as 80 million pixels; as many as 240 megabytes of disk storage are required to hold such an RGB image.

The use of a digital back requires computer skills. A digital back is not a stand-alone camera; it must be connected to a computer by a cable. The computer is used to operate the back's controls and see a preview of the image. Once a preview has been evaluated, the software can correct colors and contrast before capturing the final image. A hard drive, connected to the computer is used to save the finished image. Digital backs require more electricity than hand-held cameras and must be plugged into a wall outlet or a large battery pack. Because scanning cameras take up to two minutes to capture a single image, the light source must be very consistent; flicker-free incandescent lights are needed to illuminate a scene in a studio.

Steven Johnson

Nature photographer Steve Johnson pioneered the use of digital studio view cameras for outdoor work. He uses a 4 x 5 view camera, digital scanning backs, and a laptop computer to control the camera.

Johnson captured this image of the Grand Canyon of Arizona during his project, "With a New Eye," a digital survey of American National Parks from 1994 to 1999. Johnson's camera backs can work in color, black and white, or infrared (black-and-white), creating images of up to 6,000 x 7,520 pixels. The resulting files can be as large as 130 megabytes.

Digital view cameras use scanner-type sensors. Sensor arrays larger than 2,000 x 2,000 pixels are expensive to manufacture, so view cameras use another type of sensor. It's called a tri-linear array because the array is composed of three long lines of sensors. One line has thousands of red-filtered sensors, another has thousands of green-filtered sensors, and the third line contains blue-filtered sensors. A bar containing the three lines is slowly driven across the plane of focus, capturing information at thousands of locations. It gradually captures a three-color image composed of millions of pixels.

Scanning

Scanning creates digital images from negatives, transparencies, or prints. When images are scanned their tones and colors are converted into numbers that the software can edit. A scanner captures samples of brightness and color in a regular grid pattern. The more samples the scanner takes, the more detailed the scanned image is.

Image quality depends on the quality of the scan. Just as you can't get a good darkroom print from a poor negative, you can't get a good image from a bad scan (or a good scan from a bad negative or from a bad print). Scans made from poorly exposed or badly scratched film require extra time to edit and rarely produce acceptable results.

Just as in photography with a camera, it helps to know how the image will be used because you want each scan to give a good starting point for the editing process. If the final result is to be realistic, the scan should produce an image as close to realism as possible. If the final result is to be a colorful departure from reality, the scan should be as close to the intended colors as possible.

Before you scan an image you also need to know how it will be presented. Will the final image be viewed on a web site or printed in a publication? Will it be exhibited as a fine print, and if so, how large will it be? A digital image has no real physical size until you print it or show it on a monitor. Potentially, it may be printed or displayed in many sizes, but if you select the wrong size settings for your scanner's software, you may have an image that is unsatisfactory for your purpose. Your scanning decisions must be based on both the physical size you want and the characteristics of the printer or display device (see page 36).

KATRIN EISMANN
Glasses

Scanners create artwork that no other art technology can duplicate. Katrin Eismann used a flatbed scanner to scan wine and champagne glasses. By moving the glasses during the exposures (scanners take several seconds to scan from one side of the image to the other) she created unique distortion effects. The color effects are the result of how the scanner's hardware captures the primary colors one by one.

DARRYL CURRAN Three Red Seeds One Red "S"

For over a decade Darryl Curran has worked with constructed images.
At first he assembled the raw material for his images (sometimes by gluing the components together) and photographed them. Often he used a large studio camera, sometimes substituting color-reversal photographic paper for film to create one-of-a-kind images.

In 1993 Curran began to use large flatbed scanners to capture his assemblages. Scanners permitted him to experiment more. Seeing the image on the computer display gave him rapid feedback.

This image was taken while he was working at the imaging studio of Nash Productions, a producer of Iris inkjet prints for artists. Using materials found in the studio (the fabric, the red seeds, and an enamel "S") he evolved a composition that would depend on the computer's ability to deliver highly saturated colors.

Scanning software is simplified image-editing software. To get a good scan you should adjust the size, brightness, contrast, and overall color balance of the image. All the basic adjustments discussed in the next chapter are available in good scanning software.

There are two types of scanning software. Some scanning software is like ordinary software: You open the software and command it to find the scanner, scan the image, and save the image as a file for later editing. The other type of scanning software is the **plug-in,** which cannot be used by itself. First you open the editing software and choose File > Import (in Adobe Photoshop). You select the scanner's plug-in software from a list of image sources. Once chosen, the scanner plug-in will hide the image-editing software and display its own interface and controls. When scanning is complete the plug-in software will Quit (Exit), and the editing software will reappear with the image open and ready for editing or saving.

Alternatives to scanning. Kodak's Photo CD and Picture CD are good ways to digitize negatives and transparencies. Kodak plug-in software permits your image-editing software to open the disc's images. Service bureaus (page 113) will scan 35mm film and store the images on a CD-ROM type disc. Some companies that offer film developing and prints by mail also offer scans on a floppy disk. The images are low resolution, but may be satisfactory for small prints or for Internet use.

Making a Scan Step by Step

1. Prepare the scanner. Read the scanner manual. Scanners are complex devices that cannot be operated without instructions.

- Connect the scanner to the computer with the power on both the computer and the scanner turned off. Be aware that some types of computer cables may carry power from the computer.

- Turn on the scanner, then turn on the computer. Some computer systems require that the scanner be turned on first.

- If the scanner software is not installed, install it according to the instructions.

- If it is a flatbed scanner, make sure the glass plate is clean. Find out what the lab policy is about cleaning the glass. If you are permitted to clean it, use a cloth specifically made for cleaning optical glass surfaces.

- Dust the film or artwork . Use an antistatic brush or compressed air to clean film. Scanners are very sensitive and will capture dust spots on the film as part of the image.

- Load the film or print according to directions. Be sure to orient film so the image-bearing side is facing the correct direction.

- On the computer, open the scanner software. If you have plug-in software, open the image-editing software and launch the scanner software from the File > Acquire (or File > Import) menu.

2. Set the color mode: Grayscale, RGB, or CMYK. In some cases, you may need to set the bit depth of the scan. See the scanner instructions. For modes, see page 20. For bit depth, see page 17. For film, select negative or positive.

3. Some film scanners have a control that makes dust spots and scratches less visible in the final scan. If your film has many dust spots that cannot be removed or is badly scratched, you may wish to turn this control on. See the scanner instructions.

4. Preview the scan. A preview scan is a quick, low-resolution scan that shows you the image in miniature. It lets you plan corrections to brightness, contrast, color balance, and cropping.

5. Crop the image. In the Preview window, drag the outlines (edges) of the scanned area until only the parts of the image you want to record are within the rectangle.

Some scanner software has numerical readouts that show the changing size and pixel dimensions of the image while you drag the cropping outlines. If your software does this, you may wish to set the number of samples per inch (step 6) before previewing (see the scanner instructions).

6. Determine the size of the image and the number of samples per inch, based on how the final image will be presented (see page 36).

7. Correct the preview image for brightness, contrast, and color balance. There may be several ways to make these adjustments, depending on your scanner's software. There may be

- Slider bars for basic adjustments to brightness, contrast, and color.

- Histogram controls for precise adjustments to brightness, contrast, and color (see page 48).

- Curve controls for complex adjustments to brightness, contrast, and color (see page 72).

Most scanner software will show your changes in the Preview window. If your software does not, make a new Preview scan before the final scan to verify all your changes to cropping, brightness, contrast, and color balance.

8. Make the final scan and save the image in the appropriate format (see File Formats on page 39). If you are using plug-in scanner software, you may begin editing the image without saving first.

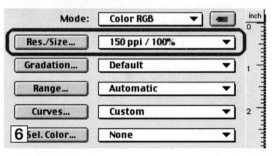

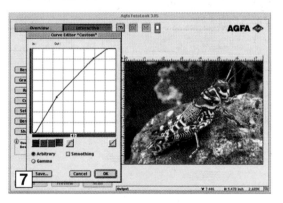

Making a Scan Step by Step

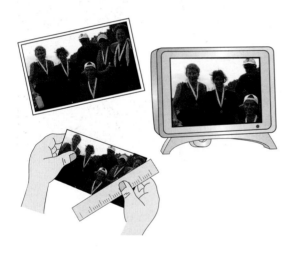

**Typical magnifications
from uncropped 35mm film**

An image in a print
12 inches ÷ 1 1/2 inches =
8 magnification

An image on a monitor
6 inches ÷ 1 1/2 inches =
4 magnification

A poster size image
48 inches ÷ 1 1/2 inches =
32 magnification

Unless you have a powerful computer, unlimited RAM, and unlimited disk storage for your files, you'll need to limit the size of your scans. Thus the scans must have no more resolution (number of pixels) than you need for the task at hand. The following is a procedure that will produce scans that have *just enough* resolution.

1. Determine the size (in inches) of the largest print you intend to make from the image. For example, you intend to make a print 10 x 15 inches.

2. Determine the cropped size (in inches) of the film or print to be scanned. For example, if you are scanning a 35mm negative with no cropping, the size of the scanned image is 1 x 1.5 inches. Some scanner software shows the dimensions of the scan. With other scanners you'll need to measure the original print or film.

3. Calculate the magnification (enlargement) by dividing the size of the final print by the size of the scanned artwork.

To get an accurate calculation, the shape of the final image and the scan must be the same. For example, a 10 x 15 print matches the shape of a 1 x 1.5-inch 35mm color slide. However, a 10 x 15 print doesn't match a 3 x 3 scan; you must change the dimensions of the scanned area to 2 x 3.

Using the example from steps 1 and 2, 15 inches divided by 1.5 inches equals a magnification of 10.

4. Determine the number of pixels per inch needed in the final print. If the image is for the Internet (or any multimedia presentation) it must look as sharp as possible. Computer monitors only display between 70 and 100 pixels per inch, so even a small amount of unintentional blurring is easily noticed and results in an unprofessional-looking image.

If you know the exact image resolution desired for your on-screen image (for example, 600 pixels wide x 400 pixels high), simply set the scanner software to scan exactly that many pixels from the film or print. *You can skip step 5 if you do this.*

For inkjet and dye-sublimation printers, as a rule of thumb, a print looks reasonably sharp if it has 200 pixels per inch. More than 300 pixels per inch are rarely useful; most people can't see such fine detail. So between 200 and 270 pixels per inch on the print is a good target number for prints that must look sharp.

How sharp does an image need to be? It depends on how it will be viewed. If an image is smaller than 8 x 12 inches it needs to look sharp, because people will view it up close. You'll not only need a scan that has enough samples per inch, but the film or print you are scanning must be very sharp to begin with, otherwise the final print will be unsharp, no matter how many samples per inch.

Some images don't need to be sharp. Poster-sized images can have fewer pixels per inch (25 to 100) because they are viewed from a distance. Oddly, the very largest images, those on outdoor billboards, may be printed with only two pixels per inch. Images that are unsharp for deliberate aesthetic reasons do not need high-resolution scanning, but the pixels in the print must be small enough to avoid creating a jagged look.

If you will be printing on a halftone device, such as a laser printer or an offset printing press, you will need to determine pixels per inch in a different way.

For a laser printer, use 2 times the manufacturer's published "screen lines per inch." To find this number you'll need to read the printer manual or find out from lab personnel. It is likely to be between 90 and 133, so your printed image will need between 180 and 266 pixels per inch.

If your image will be printed on coated paper by an offset printing press, use 2½ times the press's stated screen lines per inch. *Ask the printer or service bureau how many screen lines per inch they will print.* It is likely to be 120 to 133 lines per inch, so your printed image will need 300 or 333 pixels per inch. Uncoated paper is printed with fewer screen lines per inch, usually 70 to 100.

5. Last, determine the number of samples per inch in the scan. Multiply the magnification (from step 3) by the number of pixels per inch (from step 4). For example, a magnification of 10 for a print with 200 pixels per inch requires a scan at 2,000 samples per inch (10 x 200 = 2,000). This is your answer: Set the scanner to 2,000 samples per inch. (Remember that most scanners use the term dpi instead of samples per inch.) If your scanner won't let you set the exact number, choose the next highest number. For example, most scanners don't let you scan at 1,688 samples per inch. So select 2,000 samples per inch. You can resize the image later before you print it. See page 40 for resizing and resampling.

Magnified halftone

Typical requirements for scanner samples per inch

An image in a print
8 magnifications x 250 pixels per inch = 2,000 samples per inch

An image on a monitor
4 magnifications x 96 pixels per inch = 384 samples per inch

A poster size image
48 magnifications x 50 pixels per inch = 1,280 samples per inch

Offset printing at 120 screen lines per inch
8 magnifications x 300 pixels per inch = 2,400 samples per inch

Storing Your Images
REMOVABLE STORAGE MEDIA

Storing your file keeps it available for later use. The hard disk in your computer is useful for storing your images while you are making scans or editing them, but if you share a computer with others, the hard disk will not be suitable for permanent storage. You'll need to place your image files on some sort of removable disk that you can take with you.

Diskettes (floppy disks) are not useful for storing image files. Their small capacity (usually 1.4 megabytes) makes them useful only for small images such as low-resolution grayscale images. Because many images will be larger than the diskette's capacity, you'll need to use another storage medium.

A removable cartridge drive lets your expand your storage plus take your images to another location, such as a computer service bureau for printing. With capacities of 100 megabytes to over two gigabytes (two thousand megabytes), removable cartridge drives are a popular medium for storing images. Because the cartridges are small and relatively inexpensive, a few cartridges can contain your entire active image library.

Long-term or archival storage of images that are no longer in frequent use can be economically done on optical discs like CDs or DVDs. These discs offer lower cost per megabyte and longer data life than removable cartridge drive disks. Because of their slow speed they are less suitable for storing frequently used files.

For information on the most recent developments in storage devices, see the Appendix.

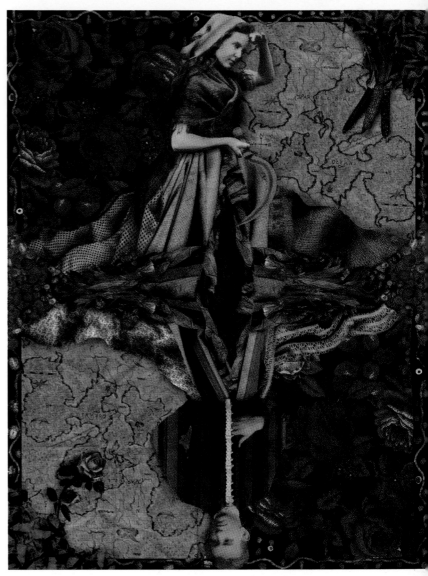

ANNA ULLRICH *August Maiden with Seeds Sown*

As digital images become more complex, with artists combining existing images to create new images, it becomes important to carefully store all of your old images for possible reuse. Even fragments of images may find their way into new images.

Anna Ullrich's image (created for a calendar published by the creators of Photoshop, the Adobe Corporation) illustrates this need. The composite image was made from two photographic images (the woman and the boy) along with images from several flatbed scans of fabrics that Ullrich had in her studio. Many additional scans of fabric were made that did not appear in the final image. In all, the process of making the image resulted in the creation of dozens of image files, all of which had to be archived since they might be useful in the future.

Top, an image saved in an uncompressed, 24-bit file format. The area enlarged below is outlined.

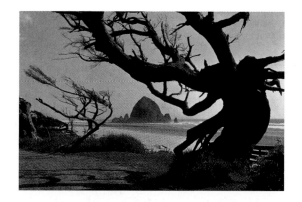

Center, a 15x close-up of part of the image above. This file is in Photoshop format. A file saved in a lossless compression format like TIFF would look exactly the same. The file size was 1.3 megabytes in Photoshop. It would be 1 megabyte as a TIFF file.

Bottom, a 15x close-up of the same part of the image after it was saved as a compressed JPEG file. JPEG allows you to choose the amount of compression. In this case maximum compression was chosen, and the file was compressed from 1.3 megabytes to 59 kilobytes, a reduction of almost 96 percent.

Note the loss of detail and the irregular, chunky shapes that have appeared in the compressed image. These are imperfections in the compression, called compression artifacts or artifacts. The more an image is compressed, the more noticeable the artifacts become. If this image had been compressed only 70 percent, instead of 96 percent, fewer artifacts would have been visible.

After making a scan, you'll need to choose how to save the image. There are a variety of ways, or formats, that the software can save the data. One of the most important features of some formats is file compression. Compression squeezes images into smaller files than they would normally occupy. This is important for images sent over the Internet, which operates very slowly.

JPEG (Joint Photographic Experts Group) is the favorite way to compress large color photographs and is an almost universal standard on the Internet. It can compress images to as little as 2 to 5 percent of their original file size, but as the degree of compression increases there is a corresponding loss of image quality. JPEG is called a "lossy" compression process because visual information is lost (discarded) in the compression process. Because of the lost information, highly compressed images show visible distortions, called compression artifacts. New developments in the JPEG file format promise improved quality and greater compression. Look in the Appendix under "Recent developments in imaging software" for the latest news about file formats.

TIFF (Tagged Image File Format) comes closest to a universal file format; most imaging software can read it. It stores images in a variety of bit depths in both RGB and CMYK. TIFF allows a small amount of file compression without any alteration of the image.

Photoshop is the unique file format created by the popular Adobe Photoshop software. It offers useful special features like storing an image in layers (see page 75). Images saved in the Photoshop format can be quite large because Photoshop saves layers and masks (page 84) as part of its files.

Resizing an Image Step by Step

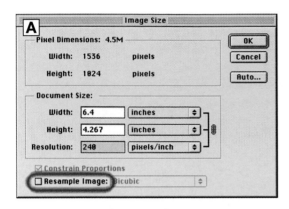

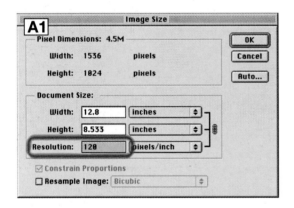

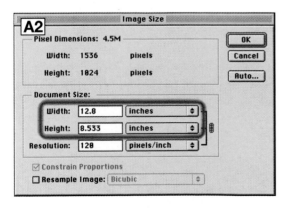

If you use an image more than once, you'll probably need to change its size. In digital imaging, changing the dimensions of an image is called **resizing.** In Adobe Photoshop resizing is done with the Image > Image Size... command.

The Image Size dialog offers two very different ways to resize the image: change the Print Size or Resample Image. Print Size does not affect the image quality or the size of the image file; it merely tells the printer to print the image larger or smaller. Resample Image fundamentally and permanently changes the image; *the computer increases or decreases the number of pixels in the image;* data is usually lost, and the file size is changed. Both procedures begin by opening the image's file.

In Adobe Photoshop, select Image > Image Size...

A. If you only want to change the print size, uncheck the Resample Image checkbox. When this box has a check in it, it changes the number of pixels in the image. Do not check this box if you only want to change the print size.

1. Change the size of the image by typing a number in the Width, Height, or Resolution (pixels per inch) field. A change to any one will update the values in the others. For example, if the current print width is 15 inches and you want a 10-inch-wide print, type 10 in the Width field.

2. Updated values for the Height and Resolution fields are automatically displayed. The Resolution value is helpful as it tells you how many pixels per inch will appear in the print, so you can estimate how sharp it will look.

B. Sometimes you must change the number of pixels in the image by resampling. If you reuse a large image for a web site, you *must* use the resampling method to make it fit on screen. An image that begins its life as a print, 2,400 x 1,600 pixels in resolution, must be made much smaller to be viewed on the web, anywhere from 90 x 60 to 1,200 x 800.

Should you resample the image or scan it again? If the resampled image will be larger than the original, consider scanning the image again at a higher resolution instead of resizing it. A rescanned image will have better quality than one you make larger by resampling.

Before resampling any image, save an archival copy of the original image. Resampling an image permanently alters it. Some of its data is discarded; a resampled image is usually not as good as the original.

To resample the image, select Image > Image Size... and

1. Check the Resample Image box. When this box is has a check it permits the number of pixels in the image to be changed.

2. Check the Constrain Proportions box. When this box has a check it keeps the shape of the image constant. Whenever you make a change to the width or height dimension it automatically adjusts the other dimension.

3. Choose Bicubic from the Resample Image pop-up menu. The Bicubic method resizes the image in a way that maintains the greatest amount of image quality. Use the faster but lower-quality methods only if Bicubic resampling takes too long with your computer.

4. Change the number of pixels. There are three ways to do this.

- Type in the number of pixels you want in the Pixel Dimensions: Width or Height fields. The print size will also change.

- Type in values for the Document Size Width or Height. The number of pixels will automatically change to match the new document (print) size.

- Type a value in the Resolution (pixels per inch) field. The number of pixels will automatically change to match the new resolution. The print size will not change.

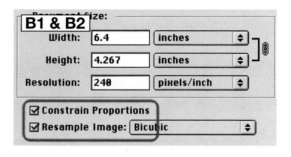

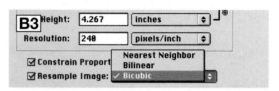

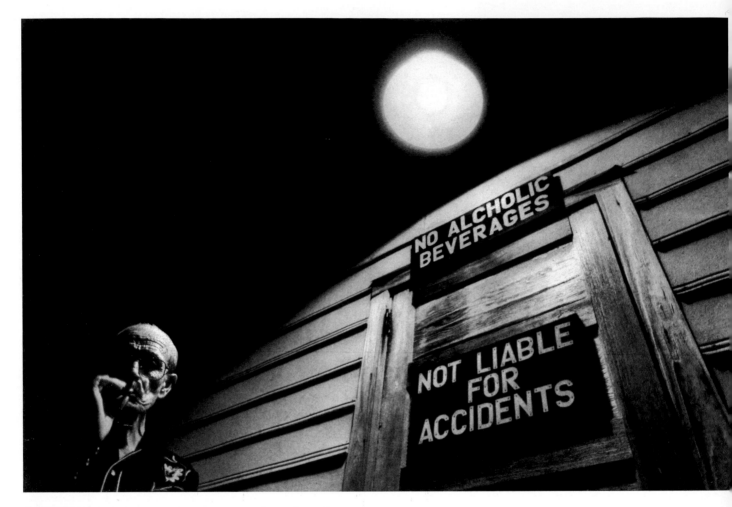

4

BASIC IMAGE EDITING

Once you have captured and stored an image, the fun begins. With digital-imaging software, anything in the picture can be altered. If you want your picture to be the ultimate in realism, you can take it in that direction. If you want to produce something that has never been seen on this earth, endless transformations are open to you.

You can edit or you can paint. Software like Adobe Photoshop has two basic capabilities. It lets you make image-editing changes to all or part of an image, such as lightening or darkening an image, sharpening or softening details, combining two or more photographs, and much more. You can also use electronic "brushes" to paint on the image, adding paint strokes, color, or special effects.

Many of the terms will be familiar—cropping, enlarging, adjusting contrast, dodging, burning, and so on. Much of the vocabulary of digital imaging was deliberately taken from mainstream photography, a sensible decision that simplifies the process of learning how digital imaging works.

In this chapter, you'll learn the basics of using software to edit images: how to adjust the tones and color of an image, how to select and edit portions of an image if you don't want to change it overall, and how to make several other changes.

You'll also learn about the software interface—the software elements that let you give commands to the computer. Very importantly, you'll learn how to calibrate the computer's monitor so its colors more closely match the colors your printer can produce.

Opposite **LAURA KLEINHENZ** Thurman Blythe

Digital processes can aid the "straight" black-and-white documentary photographer. Dodging, burning, and contrast adjustments can be done at a level of perfection impossible in a conventional darkroom. In a darkroom, it would be difficult to properly print the man's face and get deep black tones in the shadows while keeping detail in the light fixture above him. Digital editing makes it possible to get the brightness and contrast of the man's face perfect and then burn the light and the dark areas precisely. Unlike darkroom dodging and burning, digital dodging and burning will not leave any signs of the manipulation.

Laura Kleinhenz is a documentary photographer. Her image of Thurman Blythe was taken at the Lasker Grand Ole Opry in Lasker, North Carolina.

Interface

HOW YOU GIVE COMMANDS TO THE SOFTWARE

Image-editing software is the key to making image changes. Software like Adobe Photoshop is capable of manipulations that only a few years ago required a Hollywood special-effects studio. Fortunately, just as you don't need an entire photo studio to do basic photography, you don't need to use all the features of Photoshop or other powerful imaging software. The many options may seem intimidating at first, but you don't need to learn them all right away. In fact, you probably will use less than 10 percent of the software's capabilities to do 90 percent of your work.

Communicate with the software, telling it what to do, in various ways. Even if you haven't worked with graphics programs before, you'll soon become familiar with the interface elements shown here. If you need to become more familiar with computers in general (for example, performing basic tasks such as opening a file), start by reading at least the introductory chapters of a basic computer reference or your computer's manual.

Preferences are another means of instructing the computer what to do. For example in Photoshop 6, the Edit > Preferences submenu contains choices such as whether to display tools as easy-to-recognize icons (to make learning easier) or as circles and crosshairs (to precisely show the area affected by the tool), and so on. The software remembers your preferences and uses them the next time you use the tool. Other preferences modify commands, such as ones that specify what formats are used to save your files.

Image-editing software like Adobe Photoshop displays your photograph on-screen along with various tools and other options for change (see also opposite page).

The commands used to manipulate an image appear on-screen as small symbols called icons (shown in the illustration below on the right side of the screen). You can use the computer's mouse or a keyboard command to activate a tool. Many commands can be reached from the pull-down menus across the top of the screen.

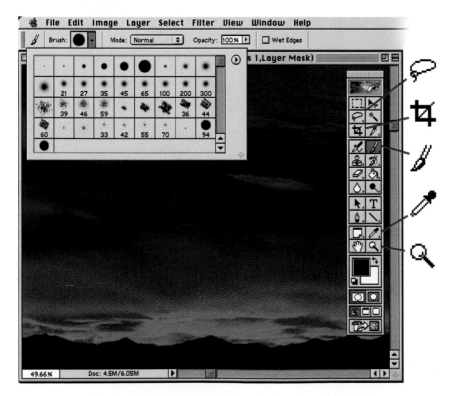

The Adobe Photoshop Toolbar

Selection tools let you isolate parts of an image to be changed. The **lasso,** for example, helps you select irregularly shaped area. The **cropping** tool lets you crop an image.

Drawing and painting tools let you paint, color, lighten, or darken parts of the image. The **paintbrush,** for example, applies color to any area it is dragged over.

Specialized tools let you perform a variety of tasks. The **eyedropper** tool picks up a color from the image and places it on a color palette. The **zoom** tool lets you increase and decrease magnification.

Tools can be customized to produce different effects. When a tool is selected in the main toolbar, additional options appear in a bar at the top of the screen. Here, the **brushes** palette appears when you click a button on the Brush options bar. From this palette you can select various brush sizes and shapes.

The options bar changes its appearance depending on the tool that is currently selected. It lets you customize the size, shape, transparency, and other significant behaviors of the selected tool.

The Toolbar contains clickable icons for the most commonly used tools, like **paintbrushes** and **erasers**. Other options also appear here, such as the current foreground and background colors.

Multiple windows. Its useful to be able to see the entire image while looking at a magnified view of a small part of the same image. If you have enough memory, you can open other images, so you can cut and paste from one image to another.

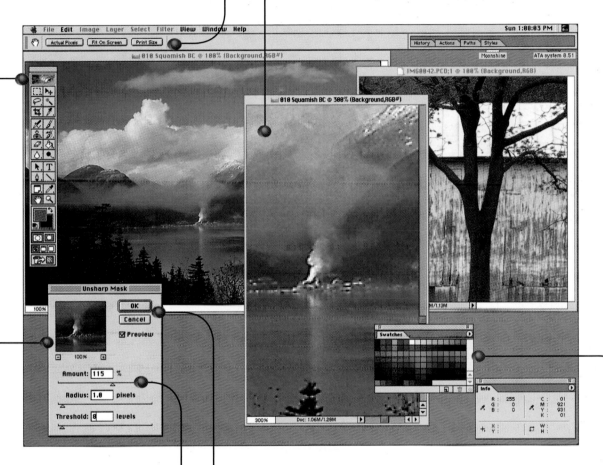

A Preview window shows you an instant preview of a change. The change may take a relatively long time to apply to the actual image, so the Preview window lets you test a variety of different effects quickly.

Dialog boxes open in response to certain commands. This dialog box lets you adjust the apparent sharpness of the image.

Palettes. These movable boxes are like dialog boxes, but they can stay on-screen while you work. **Swatch** palettes offer a place to store samples of frequently used colors. Other palettes display information about the image, such as the color values of the pixel on which the cursor is placed.

Slider bars in dialog boxes or palettes set numerical values. Using the mouse to drag a slider bar changes the numerical value of what the bar currently controls. For example, you can control the amount of the sharpening effect with a numerical slider.

Calibrating Your Monitor
MAKING SURE WHAT YOU SEE IS WHAT YOU GET

What you see is what you get—more or less. Just as darkroom prints don't show a scene exactly as you saw it, computer printers almost never exactly duplicate the tones and colors you see on your monitor. You can reduce this difference by calibrating your monitor. Calibration works by adjusting your monitor's brightness and colors to more closely match your printer's output. This reduces the time you waste making extra prints. Calibration will also help by making an older monitor more closely match the way it showed images when it was new.

Room conditions play a part. Try not to have the light in the room too bright or shining directly on the monitor. A cardboard hood around the monitor can help. Ideally, when you view a print, look at it under the same illumination under which it will be displayed. Tungsten lights will give a print a slightly reddish cast; daylight will give it a bluish one.

If you work in a lab, the monitors and printers may already be calibrated, although it's possible for someone to have changed the settings for a particular purpose. Ask your instructor if you have any questions.

Even with calibration, prints rarely match the monitor image exactly. After you make a print, compare it to the monitor. If you see, for example, that the print seems a too blue, compared to the monitor, use your image-editing software to reduce the amount of blue before making another print. For additional information about calibrating monitors and printers, see page 94.

Adobe Gamma software is a simple type of monitor calibration that will significantly improve the color balance and contrast of a monitor. Ideally, gamma correction software should be used every few months because monitors change. If you are using Adobe Photoshop, Adobe Gamma software is included with the editing software. If you are in a school lab, ask permission before adjusting the monitor with gamma software.

Gamma adjustment is a basic tool for monitor calibration. Gamma is a measure of contrast used by manufacturers of computer monitors. Gamma calibrations corrects color balance and sets the contrast for the type of output you desire.

Adobe Gamma software is part of Adobe Photoshop. It has a step-by-step procedure that helps you adjust brightness, contrast, and color balance. To use it, find and open the file named Adobe Gamma, select Step by Step, and proceed. The software will explain each step to you.

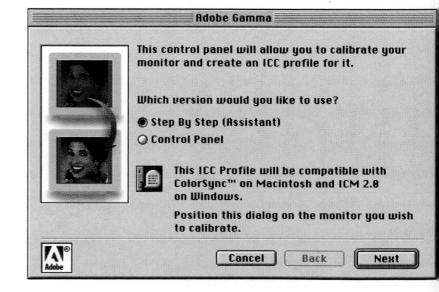

The print above was edited on a monitor (right) that was out of adjustment. Often you can't tell a bad monitor from a well-calibrated monitor. This monitor produces too much red. However, the image on the monitor *looks correct* because the photographer compensated for the extra red by removing red while editing. Unfortunately, when an image looks good on a bad monitor, the print made from it will have an equal but opposite color bias. This print has too much cyan.

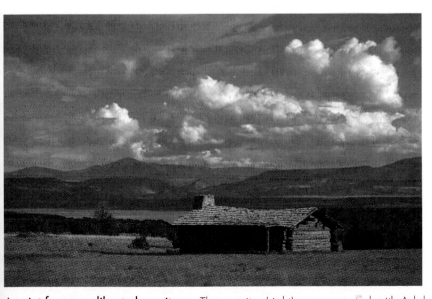

A print from a calibrated monitor. The monitor (right) was corrected with Adobe Gamma software. The gamma calibration fixed the reddish color bias of the monitor. Now when an image looks good on the monitor, its print closely resembles the image on the screen.

A well-calibrated monitor and a bad monitor may look the same; you can't tell if the monitor is OK until you make a print.

Adjusting Brightness and Contrast

Darkroom vs. digital: When you print a photograph in a darkroom, you make decisions about changing brightness and contrast after looking at test prints.

For example, you'd evaluate brightness by making several exposures on a test strip, then developing it and examining the results. You'd change contrast by using a different grade of printing paper or by changing a polycontrast filter after examining the developed test print.

With digital imaging, you make changes using various commands as you look at the image on a computer's monitor screen. Your changes are immediately visible. Don't make a print until you are satisfied with the image on the screen.

There are several ways to adjust the brightness and contrast of an image digitally. The Brightness/Contrast command (Image > Adjust > Brightness/Contrast) has the advantage of being easy to use, but it can only create a limited range of effects (see illustration, this page).

The Levels and Curves commands (Image > Adjust > Levels and Image > Adjust > Curves) are more complicated, but their effects are much more powerful and useful. Levels lets you make separate adjustments in three tonal areas—highlights, shadows, and midtones (see illustrations, this page and opposite). Curves lets you make nearly unlimited adjustments to tonal areas (see page 72).

Using the Brightness/Contrast command. Open an image in Photoshop. From the pull-down menu at the top of the screen open Image > Adjust > Brightness/Contrast. Click on the Preview box. Try making the image lighter or darker by moving the Brightness slider bar or typing a number from −100 (darker) to +100 (lighter). Try changing the contrast by doing the same with the Contrast slider bar. The image will show the changes you make.

Press OK to make the changes. Press Cancel to leave the image unchanged.

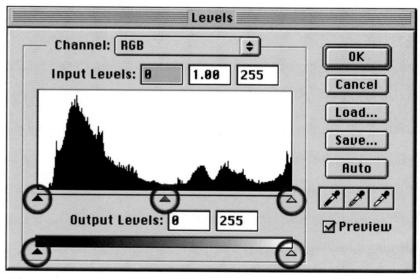

A histogram is a bar graph that shows the number of pixels at each brightness level in an image, darkest pixels to the left, lightest pixels to the right. The number of pixels at each level is shown by the height of the vertical bars. The higher the bar, the more pixels there are at that brightness level. In addition to giving you information about an entire image, a histogram can show information about the pixels in a selected part of an image.

You can change the image's brightness and contrast by moving the five triangular *sliders* (circled in red) with the mouse or by typing in numbers in the Input Levels and Output Levels boxes. The three sliders beneath the histogram (the black, gray, and white sliders) are used to lighten and darken the image, increase contrast, and to lighten and darken the middle tones. The two sliders on the bar beneath them are used to decrease contrast (see the examples, opposite).

You can change a single color's brightness and contrast by selecting the color from the Channel pull-down menu at the top of the dialog box. This lets you make changes to the color balance.

Using the Image > Adjust > Levels control to change brightness and contrast

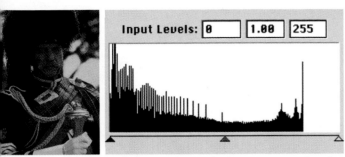

Image too dark (or too light). Above, the histogram graphically shows that the image is too dark by displaying a large number of pixels bunched at the left side of the graph. The histogram also reveals another problem: There are no pixels on the right end of the graph. This means that there are no white pixels in the image.

An image that is too light would have a histogram that looked the opposite of the one above: no pixels on the left end of the graph and many at the right end of the graph.

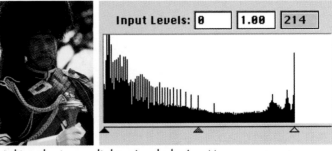

Making the image lighter (or darker). You can correct a too-dark image by dragging the white slider (the one on the right side of the histogram) to the left, which makes pixels that had been light tones of gray in the original image become pure white.

To correct a too-light image, do the opposite: Drag the black slider to the right (not shown).

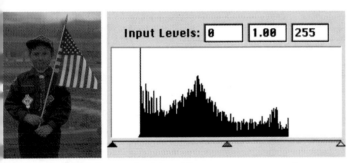

Contrast too low (or too high). Above, an image with its contrast too low. The histogram shows no pixels at either the black (left) end or white (right) end of the graph.

An image with contrast too high would have peaks of pixels at the extreme black and/or white ends of the graph.

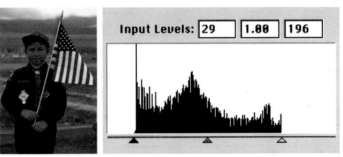

Increasing (or decreasing) contrast. To increase contrast, drag the black and white sliders toward the middle of the graph. To create a very high contrast image, try moving these two sliders very close together. Note that this picture is still too dark overall. The gray slider (shown below left) will correct this without changing the overall contrast of the image.

To decrease contrast, drag the Output Levels sliders (circled in red below the black, gray, and white sliders on the opposite page) toward the center of the graph. To create very low contrast image, try moving these two sliders close together.

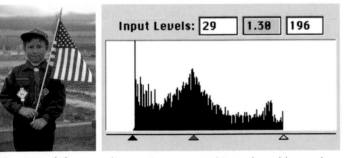

The gray slider transforms whatever pixel it is placed beneath into middle gray, a brightness value of 127, midway between 0 (black) and 255 (white).

GIVE LEVELS A TRY

Using the Levels command. Open an image in Photoshop. Use the menu command Image > Adjust > Levels. It may take a few seconds for the histogram to appear. Click on the Preview box to make the changes to the image appear while you make them.

Try making some of the changes shown on this page by moving the slider bars or typing in numbers from 0 to 255 in the Input Levels boxes. Typing in numbers will cause the sliders to move.

More About Adjusting Brightness and Contrast
USING HISTOGRAMS TO DIAGNOSE EXPOSURE PROBLEMS

There are some exposure problems that Levels can't fix. Some scans (or digital camera images) have important tonal detail missing. Shadow detail may be missing (the shadows are pure black), highlight detail may be missing (the bright areas are pure white), or both. Just as film can be underexposed and overexposed, digital camera images or scans can suffer from the same problems.

Often you can tell if an image is badly exposed by simply looking at the monitor, but its histogram will help you make a more confident diagnosis. Digital images that are over- or underexposed are said to show **clipped histograms.** The term clipped suggests that the pixels necessary for a correct exposure have been clipped off the ends of the histogram by bad exposure.

In most well-exposed and well-scanned images some pixels are found at both ends of the graph. In a clipped scan there will be a spike

of pixels (see illustration). If a scan is clipped, there is no way for editing software to fix it without hand painting details on the image or copying them from another image. Be careful not to confuse a clipped image with one that *intentionally* contains large areas of pure black or pure white. The histograms of both types of image will look the same.

If a histogram from well-exposed film is clipped, you may be able to correct it by rescanning. Consult the scanner's manual. It may have controls that let you change the exposure of the scan.

When a histogram is clipped because of bad camera exposure, reshoot the picture. Reshoot the image using fill light to reduce the scene's contrast. If an image is clipped at only one end, reshoot the picture with either more or less exposure.

PROJECT

CORRECTING SCANS WITH LEVELS

You will need a glossy photograph with deep black tones and an image from a newspaper.

Procedure Scan the two images and compare their histograms. Which histogram has no black pixels? Pretend you don't know which image produced which histogram. Could you guess which one belongs to the newspaper image? How can you adjust the image that lacks black pixels so that it has black pixels?

How did you do? You should have found that the histogram of the newspaper has no black pixels while the glossy photograph's has quite a few. To create a digital image with black tones from the newspaper scan, move the histogram's black slider to the right until the dark gray pixels turn black.

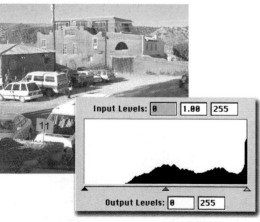

An overexposed digital camera image and its histogram. The highlight (bright) areas are clipped in the histogram. Notice that there are no pixels at the left side of the graph. This often indicates over-exposure. Adjusting the sliders will not help because no image detail was captured in the highlights.

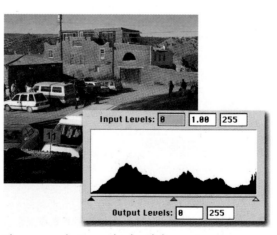

The scene photographed with less exposure. There is now enough shadow detail. The pixels at the left of the histogram represent shadow detail that was overexposed in the original exposure.

Using the Color Balance command. Open an image in Photoshop. From the pull-down menu at the top of the screen open Image > Adjust > Color Balance. Click on the Preview box.

Try making the image redder by dragging the Cyan/Red slider to the right as far as it will go (+100). Try this for Shadows, Midtones, and Highlights. Try other colors, too. Notice the effects of checking or unchecking the tiny box called Preserve Luminosity.

Press OK to make the changes. Press Cancel to leave the image unchanged.

Color Balance corrects a color cast. This scan (top) had an excess of blue in the shadows and midtones; 25 points of yellow were applied to the Shadows and Midtones (bottom).

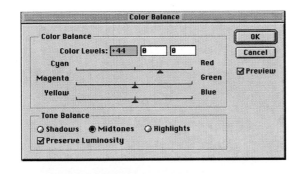

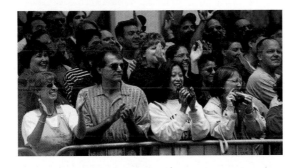

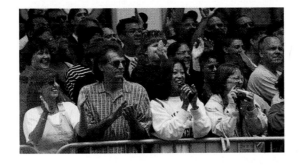

There are several ways to adjust color in an image. The Color Balance command (left) makes broad but imprecise changes. The Hue/Saturation commands (page 52) changes individual colors as well as all colors simultaneously. The Levels command (page 48) and the more powerful Curves command (page 72) give additional controls. Throughout this discussion, the color wheel (below) will help you understand what different commands do.

The Color Balance command makes changes by increasing one color while decreasing the other colors, especially the color opposite it on the color wheel (below). Like the Brightness/Contrast command, it has the advantage of being relatively easy to use. You can use it to make slight shifts or radical ones. Although everything that it does can be done more flexibly and powerfully with the more complex Levels and Curves commands, Color Balance offers a simpler way to begin learning the art of color editing.

The color wheel is a pictorial way to represent the colors that digital imaging can produce. The six primary colors (RGB and CMY) are arranged around the edge of the wheel in a sequence that shows how they blend into each other. As a color moves inward from the edge to the center it changes from highly saturated to neutral.

The Color Balance command lets you shift a color toward its opposite on the color wheel. For example, you can decrease the amount of blue in an image by increasing yellow, which is opposite blue on the wheel.

The Hue command (page 52) lets you rotate a color around the circumference of the color wheel. For example, you can make the yellows more greenish.

The Saturation command (page 52) lets you shift a color outwards toward the edge of the wheel, making the color more saturated (more intense). The command can also shift a color inwards toward the center of the wheel, which makes the color less saturated (grayer).

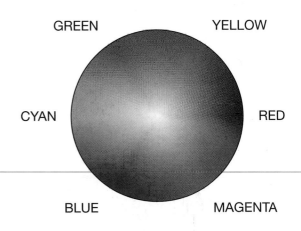

More About Adjusting Color

HUE AND SATURATION

The Hue/Saturation command. Adjust > Hue/Saturation, opens a dialog box that lets you adjust individual colors or all of the colors in an image. The command makes use of the way colors are organized on a color wheel (see page 51).

Hue refers to the name of a color—red, yellow, green, cyan, blue, or magenta. Moving the Hue slider (or typing a number in its box) makes a color resemble its neighbor on the color wheel.

Saturation refers to the purity of a color. The colors toward the outside of the color wheel are more saturated and intense than those grayed-out colors toward the center of the wheel. The Saturation slider (or the value you type in its number box) increases or decreases the saturation.

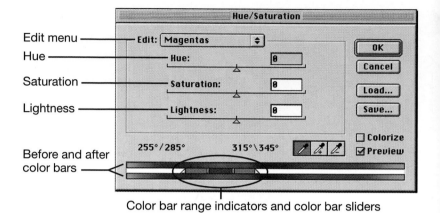

Edit menu
Hue
Saturation
Lightness

Before and after color bars

Color bar range indicators and color bar sliders

The Photoshop Hue/Saturation dialog box

Edit menu shows the name of the color that will be changed. If Master is selected, all colors will be changed.

Hue. Moving the Hue slider changes the hue either a little or a lot. If you think of the color wheel as a circle of 360 degrees, changing the hue + or −10 will shift a color very slightly. Changing the hue + or −180 will change a color to its opposite on the color wheel.

Saturation. Moving the Saturation slider changes the color's saturation. A value of −100 will make it gray. A value of +100 will totally saturate the color.

Lightness. Moving the Lightness slider to the right changes the color by lightening it. Moving the slider to the left does the opposite; it darkens the color.

The before and after color bars arrange the fully saturated colors found on the edge of the color wheel in a straight line. The top bar shows the colors **before** you make changes. The bottom bar shows what happens to the colors **after** you make changes.

Color bar range indicators and sliders let you see and modify how much of the color bar will be affected by your changes to the currently selected color. The inner dark gray bar shows the range of colors fully affected. The two lighter gray bars show the edges of the zones where the effect falls off from full intensity to zero. You can change the ranges by dragging the bars and sliders.

Color correction with the Hue command. Above left, an image with a common problem: too much cyan in the blue sky. Below left, the corrected image.

Setting the Hue slider for the color cyan to +53 shifts the cyan sky to the desired shade of blue.

GETTING FARTHER AND FARTHER FROM REALITY

You will need A digital image of a scene or a person. A color printer.

Procedure Make the image as realistic a representation of the subject as possible.

From the same image make a colorful departure from reality.

Use the Hue adjustment to create new colors. Use the Saturation adjustment to emphasize or deemphasize colors. Use Levels if you need to make tonal adjustments.

See how far you can take the image.

Hints: Save copies of the unreal image as you work. If you don't like what you get and feel you spoiled the image, go back to an earlier version and start in another direction. Keep notes of the changes you made.

Print both the realistic representation and the unreal one. If you can, print some of the intermediate versions.

How did you do? How did changing the colors affect the feeling or mood of the image?

Bonnie Kamin

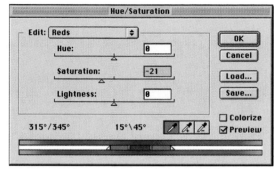

Using Saturation to correct color. A Saturation adjustment can be used to change a single color. An image with too-vibrant reds (top left) was corrected (left) by using the Saturation adjustment to reduce the red saturation. Above, the Saturation adjustment set to decrease saturation by 21, a medium amount.

EXPERIMENTING WITH THE HUE/SATURATION COMMAND

Open a realistic image in Adobe Photoshop. From the pull-down menu at the top of the screen open Image > Adjust > Hue/Saturation. Click on the Preview box so the image will show the changes you make.

With Master (all colors) selected from the Edit menu, adjust the hues by moving the Hue slider. Notice that the colors in the image reverse when + or −180 degrees is chosen. Watch how the "after" color bar changes as you change hue. When you are done, return the slider to 0 and try the Saturation slider. Notice how the amount of saturation changes from none (at −100) to extreme (at +100).

Choose the *one* color that is most prominent in your image. Select that color from the Edit menu. Try changing the hue and saturation in the ways described above. Try using the Lightness slider to change the lightness of the color.

Move the color range bars and sliders. There are many possibilities here, so just experiment and see what happens.

Is any color missing or nearly missing in your image? If so, select that color from the Edit menu and try the changes described above. If the color is entirely missing, nothing will happen to your image. But you may be surprised—areas where you didn't think the color was present may show changes.

Finally, try to improve the image using changes to hue and saturation.

Editing an Image Step by Step

1. Evaluate the image visually. Open the image on a computer whose monitor has been calibrated. Evaluate the image's brightness and contrast. Is the image too light or too dark? Is the contrast too high or too low?

This example image is too dark. Other defects may be revealed once the image is made lighter.

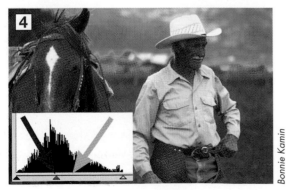

2. Evaluate the image with Levels. Use Image > Adjust > Levels (histograms) to get more information about the image. Evaluate the highlight and shadow pixels.

The Level's histogram shows that the image has no white tones, or even light gray tones. This means that it is too dark and has low contrast. Thus examining the histogram has confirmed the visual evaluation.

If the image is clipped (page 50), scan it again or reshoot the image. Remember that an image that *intentionally* has large areas of pure black or white should not be diagnosed as clipped.

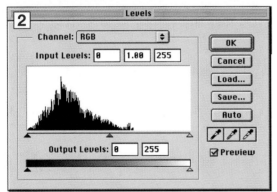

3. Adjust the contrast and brightness with Levels sliders. Adjust the white and/or black sliders to improve the contrast and brightness, using both your aesthetic judgment of the image and a technical evaluation of the histogram.

The white slider is moved to the left until the on-screen appearance of the light tones is correct. Because the dark tones are OK, the black slider does not need to be moved.

Don't unintentionally clip an image when you increase its contrast. Remember, when you move a white slider to the left, all the pixels to the slider's right will be clipped (made white). Unless this effect is desirable, be careful to avoid it. (The black slider will clip all pixels to its left.)

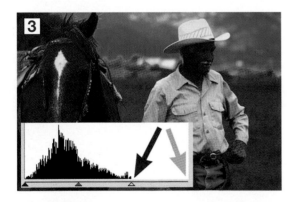

4. Adjust the gray tones with the gray slider until the mid-tones of the image look correct.

In this image, the gray tones are a little dark, even after correcting with the white point. As a result the image feels "heavy." Moving the gray slider to the left gives the midtones a lighter appearance.

Bonnie Kamin

5. Evaluate the color balance. There are three basic commands you might use to improve color balance. Which one (or which combination) is best will depend on the individual image. You may

a. use the histograms of the individual color channels (Image > Adjust > Levels) to balance colors, or

b. use the Image > Adjust > Color Balance adjustments to balance serious color casts, or

c. use Image > Adjust > Hue/Saturation adjustments to balance severe color casts.

In this image, the tool that does the best job of correcting the color balance is Color Balance. There is too much green in the highlights (the lightest tones of the image), so the Color Balance tool is used to shift green to magenta (green's opposite on the color wheel) in the highlights.

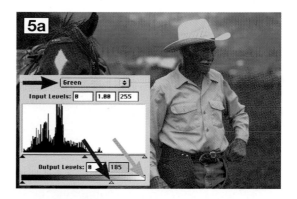

6. Evaluate the color saturation. Use Image > Adjust > Hue/Saturation if the saturation is excessive or insufficient.

This image's colors are too saturated. Moving the Master Saturation slider to –20 decreases the saturation of all colors equally. In many cases you only need to adjust the saturation of individual colors.

In some images the saturation is so high or low that you need to adjust saturation first before Step 5.

Saturation Tip: When contrast was increased in Step 3, it increased saturation. Saturation and contrast are linked in principle: Saturation always increases when the image's contrast increases, and saturation always decreases when the image's contrast decreases.

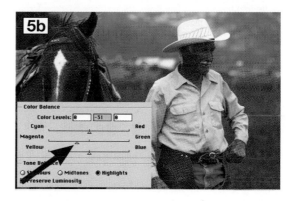

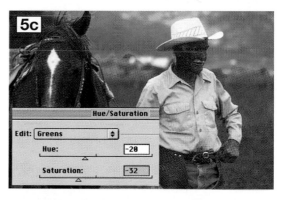

ENHANCEMENTS TO THE BASIC PROCESS

You can use the **Variations** command (Image > Adjust > Variations) to preview the effects of adjustments to Brightness, Color Balance, and Saturation.

Advanced tools discussed in chapter 5 may replace some of these. The **Curves** control (page 72) is superior to Levels for adjusting brightness, contrast, and individual colors. Making all changes to Levels, Color Balance, Hue/Saturation, and Curves within **Adjustment Layers** (page 79) is usually the best way to manage these corrections because it protects the original image data from irreversible changes.

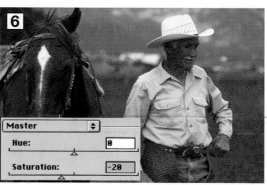

Bonnie Kamin

TO26870

Selections

Defining an area to be changed

The power of selections. Have you ever cut out parts of several pictures and pasted them together into one image? Or have you ever had a portrait in which you wished you could somehow eliminate or gray out the background? Or have you had a picture in which you wanted to lighten a shadow on the face of a friend, or a landscape in which you wished the sky was darker? You can do all of these with image-editing software.

The first step to making changes like these is to tell the imaging software what parts of the image you want to work with. This process is called selecting an area of the image or simply **making a selection.**

There are many ways to make a selection. If you've used word processing programs you know that to edit text you can use the mouse to drag the cursor across the words or letters you want to change. In digital imaging you can do almost the same thing; you can draw an outline around the area you want to change with a selection tool (see opposite page). There are other ways to select parts of an image. You can tag a pixel (or several pixels) in the image by clicking it with a selection tool, and command the

computer to select other pixels that resemble the color and brightness of the pixels you clicked (see page 58). Once part of an image is selected, there are many ways to modify the selection (see page 60).

You can save your selections. This means you can save the selection outline for use later — in two minutes or two years. This is a great labor-saving feature. It also prevents frustration, since some kinds of selections, like outlining with a cursor, are very time consuming to make. Adobe Photoshop saves selections as channels (see page 86 for channels). By the way, if you are using Adobe Photoshop and you accidentally erase a selection, the command Select > Reselect restores the last selection you made.

You can use selections to get information about a part of the image. If you select an area of the picture and then choose the Image > Histogram command, the histogram will display information about the pixels in the selection only. This lets you learn about the contrast, brightness, and color balance in the selected area.

WHEN YOUR SOFTWARE TOOLS QUIT WORKING

WHEN YOUR SOFTWARE TOOLS QUIT WORKING

When you begin working with selections you may experience moments when the software suddenly stops functioning. For example, you may try to use a brush tool to paint on the image, but the brush refuses to paint.

The software may be ignoring the brush tool because you are painting outside a selection — a selection you created by accident or one you forgot about. *The brush will only work inside the selection.*

Check for a hidden selection. First look carefully at the image to see if a selection is visible (look for the moving marquee). If you don't see one, pull down the View menu. Is the command View > Show > Selection Edges checkmarked? When there is no checkmark beside the command Selection Edges (a minus sign appears instead), it means **that there is a hidden selection** in the image. Click View > Show > Selection Edges to make the selection visible.

To deselect a selection, use the command Select > Deselect. Your brush will now work anywhere in the image.

The boundaries of a selection are shown on the monitor as a moving line of black-and-white dashes called the selection marquee. These "marching ants" show the area that will be changed by a command or a tool. Outside the selection nothing will be affected.

At times the selection marquee can be a distraction, and you may prefer to work without it. You can temporarily hide the selection marquee by choosing View > Show > Selection Edges. You can make the marquee reappear by choosing View > Show > Selection Edges again.

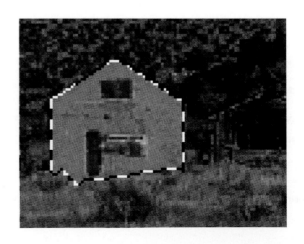

Drawing selections with the cursor

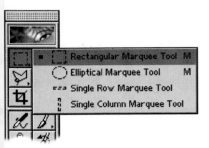

The rectangular marquee draws rectangular and square selections. Click a starting point and drag the cursor to create the rectangle.

The elliptical marquee draws elliptical and round selections. Click a starting point and drag the cursor to create the ellipse.

The lasso creates a selection boundary wherever the cursor is dragged—it can create large irregularly shaped selections. Drawing large selections with the lasso is tedious, so the more advanced Pen tool (page 82) is often used instead.

The polygon lasso draws multisided, irregular selections with straight sides. A new corner (angle) is created wherever the mouse is clicked. An optional command will smooth the corners and curve the lines.

You can draw selections with a mouse. To draw a selection, pick a tool by clicking on its icon in the main toolbar. At left are some of the most frequently used selection tools.

You can customize the way the tool operates. When a tool is chosen, the options bar for that tool appears. Options bars contain controls that modify the effects of the tool. One such option is to give the selection either sharp or fuzzy edges.

Other modifications can be selected by holding down modifier keys (such as Shift, Alt, and Option) while drawing. These keys make it possible, for example, to draw rectangles from the center instead of the corner or to combine a newly-drawn selection with an existing one.

PROJECT: SEPARATING A SUBJECT FROM ITS BACKGROUND

You will need An image of a person in a place. The person should not be small in relation to the surrounding image. The image should be at least 600 x 400 pixels but not larger than the screen at 100 percent magnification.

Procedure Choose the Lasso. On the options bar, select a feather radius of 5 pixels. Then outline the subject with the Lasso tool. Don't trace the edges; draw a very simple and smooth selection outline a small distance *outside* the edge of the subject.

When you are done, go to Select > Inverse. This will reverse the selection and select the area around the subject instead of the subject.

As it may make many revisions before you create a satisfactory image, use Select > Save Selection, naming the selection "Outline."

Now you can use any tool to change the area around the subject. Try different setting of Color Balance, Hue, Saturation, and Levels. Experiment until you have created something that emphasizes the subject in an interesting way. If the outline is accidentally erased, Selection > Load Selection will retrieve it.

How did you do? You should have created an image in which the subject is unchanged. The surroundings should look completely different. The boundary between the subject and the surroundings should appear as a soft and gradual transition.

Selections

Automatic selections. You can select parts of the image that resemble the color and brightness of a pixel you click on.

The magic wand is an easy-to-use similarity selector. When you choose the magic wand from the toolbar and click on a spot in the image, the computer records the brightness and color of the pixel you clicked on. Then it selects other pixels that are similar to it in brightness and color.

The magic wand's options bar (below) lets you specify what similar means; by typing a number (0 to 255) you set the tolerance range. You can select pixels from a very narrow range of similar colors and tones or from a very broad one; the smaller the tolerance range, the more the selected pixels will resemble the pixel you clicked on.

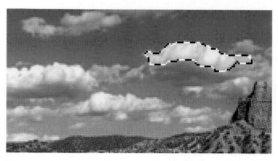

The magic wand selects pixels of similar colors and brightness. In this illustration, the wand is clicked on a white pixel; thus all white pixels plus pixels within the tolerance range (48) are selected.

Why aren't the white pixels in the other clouds selected? Because when the Contiguous option is active (checkmarked in the magic wand options bar), the pixels in the blue sky between the white clouds must also be within the tolerance range, or else the magic wand will not "bridge the gap" and select the other cloud's white pixels. In this image, the selection is surrounded by a "moat" of pixels too dark to be selected.

Like other selection tools, similarity selection tools let you add to or subtract from existing selections. If you want to select the nearby white cloud but do not want to increase the tolerance range or use the Contiguous option, click a white pixel in the other cloud while holding down the Shift key.

Holding down the Shift key while making a new selection adds the new selection to the old one. Conversely, holding the Option (or Alt) key while clicking *subtracts* the newly selected pixels from the original selection.

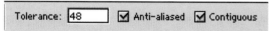

The options bar for the magic wand. The Tolerance setting determines which pixels will be selected. A low Tolerance setting (like 10) will select only pixels that are very similar in brightness and color to the pixel you click on; a high Tolerance setting (like 120) will allow more pixels in the selection.

If the Contiguous box is checked, the magic wand will select only pixels that are connected to the pixel you clicked by a "bridge" of pixels within the tolerance range. If the clicked pixel is completely surrounded by pixels that are not within the tolerance range, pixels in other parts of the image will not be selected. If Contiguous is not checked, all pixels within the tolerance range will be selected.

When Anti-aliased is checked, the selection will be surrounded by a border of partly selected pixels (see page 61 for more about anti-aliased selections).

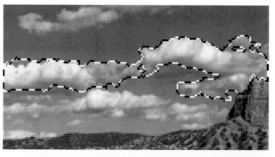

The results of increasing the tolerance. The magic wand was clicked on the same pixel, but with the tolerance range increased from 48 to 96. Some light blue pixels in the sky are similar enough to be included in the selection, so a bridge is formed that allows a neighboring cloud to be selected.

Correcting a bad scan with Color Range.
When this desert sunrise was scanned the yellow sky at the top appeared green. Color Range can fix this.

First the area containing the color cast is roughly selected by outlining (top) so that the other areas will not be selected. Then the Select > Color Range command is chosen.

Next, the green areas are clicked with the mouse. By holding the shift key while clicking, many shades of green are added to the selection.

You can see the selection in miniature in the Color Range dialog box. The selected areas are white, and the partially selected areas are gray (second from top).

To see the selection in more detail you can apply a colored overlay (a mask) to the unselected areas of the image itself by choosing a mask from the Selection Preview pull-down menu. A white mask is shown (third from top).

After completing the selection, a color correction is applied to the selection. The Hue command (Image > Adjust > Hue/Saturation) is chosen, and the green hue is changed to a sunrise yellow.

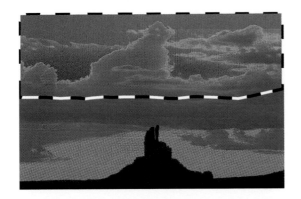

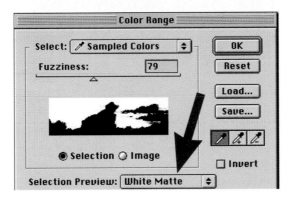

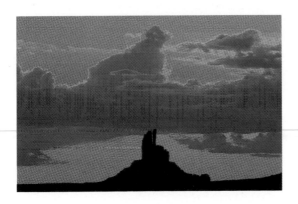

The Color Range command, Select > Color Range, selects all pixels in the image that are like the sample pixel(s) clicked on.

Partial selection. Unlike the magic wand, selection by Color Range *partially* selects pixels, based on how closely they match the clicked-on pixel. If, for example, the pixel clicked on is bright red, then all bright red pixels will be 100 percent selected. Darker reds and bright oranges will be 30 percent to 70 percent selected. Very dark reds might be only 10 percent selected. The Fuzziness setting, a slider in the Color Range dialog, allows you to numerically define the range of partially selected pixels.

Partial selection extends the capabilities of other commands, such as Color Balance, Hue, and Saturation. Since these commands can be applied to partially selected pixels, their power is given an additional dimension. For example, if the lightest pixels in an image are selected by Color Range and then Adjust > Hue/Saturation is chosen, the saturation of the highlights will be changed a lot, the saturation of the midtones a little, and the shadow saturation will be unchanged.

Color Range lets you select within a selection. Ordinarily, Color Range selects similar pixels everywhere in the image. But if a selection already exists, Color Range will select only within that selection. This is useful if you want to edit only one part of the image (see left). If you want to add a Color Range selection outside an existing selection, hold down the Shift key while choosing the Color Range command.

Selections

You can increase or decrease the size of a selection. The changes do not have to be made with the original selection tool; you can lasso a selection, add areas to it with a color selection tool, and then shrink it with the Contract command. The following commands are from Adobe Photoshop 6:

Expand and Contract. Select > Modify > Expand or Contract makes the selection grow or shrink in every direction by the number of pixels you specify in a dialog box.

Grow. Select > Grow operates like a magic wand. It selects neighboring pixels in the image that resemble those in the existing selection. Tolerances are taken from the magic wand options bar.

Similar. Select > Similar selects pixels in the image that resemble those in the existing selection, but (unlike the Grow command) the pixels do not need to be physically connected by similar pixels. Tolerances are taken from the magic wand options bar.

Border. Select > Modify > Border changes the selection, which is a solid area, into a hollow ring or donut shape (see below). The thickness of the ring is specified in a dialog box.

Feather. Select > Feather gives the selection soft edges, so that pixels at the edge are partly selected (see opposite) while pixels at the center are completely selected.

Inverse. Select > Inverse reverses the selection status of every pixel in the image. Selected pixels become deselected and unselected pixels become selected.

Hide Selection Edges. View > Show > Selection Edges. This command hides the "marching ants" selection marquee; the selection is still there but hidden. This is useful when you need to compare the selection to the surrounding area while making changes. Remember to restore the marquee by choosing View > Show > Selection Edges again or you might forget that there is a hidden selection.

Repairing an edge with the Borders command. In this image the sky was selected and darkened with Image > Adjust > Levels. Now, the mountain top looks unrealistic—the selection's sharp edge is visible.

Because the sky is still selected, the Select > Modify > Border command is used to create a new selection, four pixels thick.

Image > Adjust > Levels is used to lighten dark pixels in the border. The top of the mountain now looks natural.

Partially selected pixels. Ordinarily, pixels are either completely selected or completely unselected. A few selection tools, however, create partially selected pixels. Partially selected pixels are extremely useful in editing. For example, a narrow zone of partially selected pixels at the edge of selection will create soft gradations between the edited and unedited areas. Soft gradations make your edits appear to be a natural part of the picture.

Feathering and anti-aliasing Two ways to create selections with partially selected edges are anti-aliasing and feathering. Anti-aliased selections are surrounded by a one-pixel-wide ring of partially selected pixels. Feathered selections have thick borders of partially selected pixels. The width of the border can even be big enough to let you create such features as vignettes.

A school bell tower edited without anti-aliasing. The blue sky has been lightened with anti-aliasing turned off. The edges of the sky are visibly sharp and saw-toothed.

With anti-aliasing. Anti-aliasing makes edges appear soft and fuzzy. To create an anti-aliased selection, click Anti-aliased in the selection tool's Options bar (see right).

The options bar of the lasso tool. Feathering and anti-aliasing are available options. In the Feather box, you enter a number; the width of the feathered zone will be several times this number. Other selection tools offer similar options. You can also feather a selection after it is created (see the illustration at left).

An unfeathered vignette created by a selection. An oval-shaped selection is drawn in the center of an image with the elliptical marquee. Then the oval is deselected and everything outside it selected, with the Select > Inverse command. The Edit > Clear command erases the selection, leaving a white border.

Feathering. In this image, the same process is used except that after the first selection, Select > Feather is chosen. The Feather number is set to 100. This causes a zone of partially selected pixels approximately 260 pixels wide, centered on the edges of the selection. When the selection is cleared the edges are soft.

Selections
CROPPING AND TRANSFORMING SELECTIONS

Selections can be used to crop an image. In Adobe Photoshop 6, cropping can be done with the crop tool found near the top left position of the toolbar; cropping can also be done by drawing a rectangular selection and choosing Image > Crop.

Many images need to be rotated. Film and prints can easily be misaligned in a scanner, and often cameras are not held level. As a result, architectural elements or the horizon may appear tilted. To correct this you can rotate the entire image (see below).

You can change the shape of images to correct errors in perspective or for creative purposes. Ordinary 35mm camera lenses cannot correct for perspective. When a camera is pointed up at a tall building the picture it takes will show the building's sides converging toward the top of the image. Perspective controls in software (right) can correct this; the sides of the building will appear parallel.

Correcting perspective

A church in rural New Mexico on Christmas Eve looks askew because the photograph was made with an ordinary wide-angle lens that was pointed upwards. The vertical lines of the walls and window frames should appear parallel but they converge due to distortion.

The perspective is corrected with software. The entire image is selected and then the Edit > Transform > Perspective command is used: The top corners of the image are dragged outwards until the building's vertical lines look parallel. As a result the shape of the picture is changed, but it can be made rectangular again by using the Crop tool.

The tilted horizon line is a distraction in the image below. The entire image is selected and the command Edit > Transform > Rotate is chosen. The mouse is used to drag the corners of the image until the horizon appears level. At right is the corrected version. The image will need to be cropped to restore its rectangular shape.

ANNE SAVEDGE Fountain Frieze 1

Some of the ethereal quality of Anne Savedge's image of people playing in a fountain comes from the elongation of the human figures. She combined six separate images made at a city fountain and then distorted the image's shape by scaling it vertically.

Scale

Skew

Distort

UNLIMITED TRANSFORMATIONS

Besides Crop, Rotate, and Perspective, Adobe Photoshop offers several ways to transform a selection or an entire image.

Edit > Transform > Scale permits enlarging or shrinking a selection by dragging its corner horizontally and vertically. Holding the Shift key while dragging keeps the overall shape the same while changing the size.

Edit > Transform > Skew transforms a rectangular selection into a parallelogram by dragging its corner horizontally or vertically.

Edit > Transform > Distort permits you to make unlimited freeform distortions to a selection by dragging a selection's corner in any direction.

The options bar lets you make transformations with numbers that you type in, rather than by dragging corners. This can be useful when exact angles are required. Numeric input can scale, skew, and rotate the selection. It can also simply nudge (move) a selection horizontally or vertically.

Brush Tools
PAINTING ON AN IMAGE

Software doesn't limit you to photographic effects. Ever since the invention of negatives and printing paper in the 1850s, photographers have been painting and drawing on their pictures. Imaging software lets you paint and draw with a freedom those early photo-illustrators never had. Today there's no longer a practical distinction between digital illustrators and digital photographers because they use the same tools to create their work. While it's outside the scope of this book to cover photo-illustration techniques, some painting tools are useful when working with images that are intended to look photographic.

Paintbrushes, airbrushes, pencils, erasers, smudge tools, dodge and burn tools, and clone stamps are all brush tools. Brush tools change the color and tones of the pixels that they are dragged over. "Brush" is really just a descriptive term for the way that the software lays down color or special effects when you drag the cursor across the image; you have the feeling of applying color just as if you were using a paintbrush. However, no physical brush is as adaptable as a digital brush. Digital brushes have changeable shapes; they can be round, elliptical, or any size or shape you wish—you can even customize brush shapes to look like teddy bears and airplanes. You can change a brush's transparency (to produce solid or see-through color) and the softness of its edges (the color at the edge can be as solid as that of the middle of the brushstroke or more transparent). Color from a brush can flow smoothly or it can sputter and create droplet effects, like those of an airbrush.

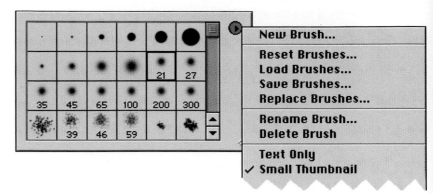

The Brushes palette and its options menu. The palette is used to store a variety of brush sizes and shapes. By clicking on a brush in the palette, the tool you are currently using (for example, the clone stamp tool) will take on that brush's size, shape, and angle. The software will remember the last brush characteristics used by each type of tool. Clicking an empty area will open the Brush Options dialog box (below).

The menu item Define Brush transforms a selection into a custom brush shape. This cookie cutter-like command lets you turn unusually shaped outlines (such as those of people or animals) into brushes. (From the Brushes palette, click the Brush menu button > Define Brush.)

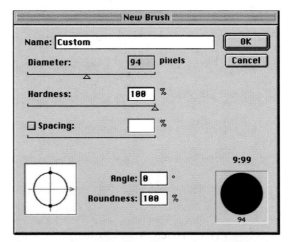

If you need new brushes, the Brush Options dialog lets you create them. Brush Options lets you specify the size, shape (round or elliptical), tilt angle (if it's elliptical), and edge hardness. If Spacing is selected, the brush will not flow smoothly; instead it will paint a repeating series of brush marks. A slider lets you set the distance between the brush marks.

The Swatches palette stores colors that the brushes can use. The colors might be used to paint directly onto the image, or they may be used in rainbowlike multicolor gradients.

When the cursor is positioned over one of the small colored samples, pressing various keys will make the current brush adopt the color, paste a new color into the palette, or delete the color from the palette.

Customized swatches can be made and reused by saving them as files and opening them as needed. This makes it possible to have an unlimited number of swatches.

There are auxiliary tools that help you use paint tools.

Color palettes store samples of often-used colors. The toolbar palette contains only two, the foreground color, which is the one that is currently in use by the paint tools, and the background color, which is the color that will appear if the Eraser tool is used. The Swatches palette (see left), Window > Show Swatches, is the master color palette. Custom colors can be added to the Swatches palette.

Color pickers are dialog boxes that let you create new colors to put on the color palettes. Color pickers let you click on, or numerically specify, any color that the software can create. One color picker dialog can be opened by clicking the foreground or background color swatches in the toolbar. An alternative color picker can be opened with the Window > Show Color command.

The eyedropper tool is used primarily to pick up colors from parts of the image or from palettes and transfer them to brushes or other palettes. The eyedropper icon is found in the toolbar. It has its own options bar whenever it is the active tool.

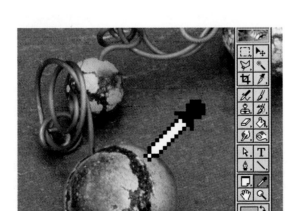

The eyedropper tool is used to sample (pick up or copy) colors and place them into a palette or directly into a brush. It can pick up colors from an image, from a swatch, or from a color picker. In this illustration, the eyedropper is used to take a color from an image and place it in the foreground color on Photoshop's Toolbar palette.

Using Brush Tools
APPLYING PAINT AND SPECIAL EFFECTS

Brushes do more than apply paint. Brush tools can apply special effects that have little to do with painting. For instance, brushes can increase or decrease color saturation. By dragging a brush across an image, saturation can be increased or decreased beneath the brush; if you drag the brush over a spot repeatedly, the effect will be intensified.

Brushes are also used for dodging and burning, swapping colors, and even sharpening or blurring details. Smudge brushes let you finger paint, pushing the colors and tones across the picture as if they were wet paint on a canvas. The clone stamp lets you copy a part of an image and paint it onto another part of the image, or even onto another image. The abilities of brushes to manipulate colors and tones are so varied that there are hundreds of ways in which brush tools and photographic effects can be combined.

Applying color from a palette is the most basic brush function. The color applied by a brush can be opaque (solid) or semitransparent. The options bar of most brush tools contains a numerical slider that lets you change opacity from 100 percent (solid) to 1 percent (so thin that you may not see it).

Above, a semitransparent layer of red-orange (60 percent opacity) is being brushed over an image with the paintbrush tool.

Painting with colors to correct defects like scratches and dust is a common beginner's error. Paint does not look photographic (for example, images have grain but paint is smooth) and painting is very time-consuming. Using the clone stamp tool (page 68) is faster and gives better results.

The paintbrush can apply special effects like the Color mode (colorizing) shown here. In this image the brush applies an orange color (sampled from the woman at right with the eyedropper tool) to the man's shirt. The brush is not erasing the details on his shirt; it is replacing the existing bluish color while leaving the patterns of light and dark unchanged. This is similar to Hollywood's colorization of old black-and-white movies.

The pulldown menu in the paintbrush's options bar shows almost 20 effects that the paintbrush can apply. Like Color, many of them work in conjunction with the currently selected foreground color. For example, Color Dodge will lighten the brushed area while tinting it with the currently selected color.

Other brushes have similar sets of effects. See the blur tool, opposite.

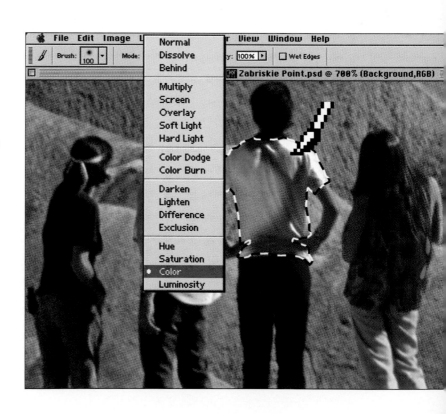

Unusual and imaginative combinations of effects are available from the modes menu in the options bar of most brush tools. The **blur tool,** for example, not only blurs normally (creating an out-of-focus effect), but it also allows darkening or lightening at the same time.

Far left, an image before blurring. Second from left, the top two thirds of the image blurred with a brush set to blur normally. Third from left, the blur brush set to blur plus darken. Right, the blur brush set to blur plus saturation (color). Note that the colors seem to smudge while the details remain unblurred.

JILL GREENBERG Untitled

For an assignment to make an illustration for a magazine article, Jill Greenberg used an inventive mix of traditional studio photography techniques and digital editing. The basic distortions were created by photographing the man reflected in a sheet of twisted, mirrorlike mylar plastic. Digital retouching improved on the basic image and intensified the colors; brush tools were used to paint smaller features. Photoshop's smudge tool was used to create the small, curving distortions of the man's head.

Cloning

COPYING FROM ONE PART OF AN IMAGE TO ANOTHER

The digital effect that seems the most magical is cloning. The clone stamp tool (which is sometimes called the rubber stamp tool) is a brush that lets you copy pixels from one part of the picture and paint them into another. Adobe Photoshop (5 and later) even lets you clone from one image into another.

The clone stamp tool has many uses. It can be helpful in repairing scans made from damaged originals, such as a torn or creased print or scratched and dusty film. It can remove unwanted objects, for example, deleting a telephone pole and leaving empty sky.

The clone stamp can repair defects, such as dust spots or crease marks. Used this way, it paints with a copy of another part of the image. Usually the copied spot is an undamaged region only a short distance from the area being repaired; this lets you observe both the source and the repaired area at the same time. In this illustration, the icon is the brush of the clone stamp tool; the cross hair is the center point of the source (the area being copied). As the brush moves, the source moves in tandem, in exactly the same direction and at exactly the same speed.

The clone stamp tool is sometimes used to remove entire objects from an image. When this is done it is necessary to create a convincing replacement in the space where the object was. Replacements can usually be created from a composite of several surrounding features. Architectural elements are relatively easy to simulate convincingly, but even complex creations such as trees take only a little more time.

Ethical dilemmas arise when the clone stamp is used to create a false reality. Photojournalists aren't the only photographers whose work is expected to be truthful. Nature photographers have begun questioning the ethics of clone stamping, such as removing signs of humans from "wilderness" photos—airplane contrails, power lines, and distant buildings. Other practices raise even more troubling questions. How would you feel if you discovered that undesirable features had been removed from travel-brochure pictures of a resort you visited?

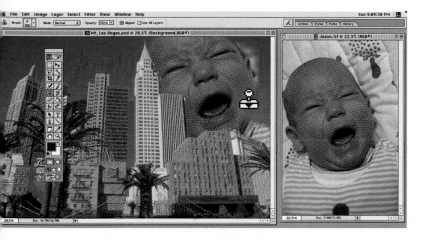

The clone stamp tool in Adobe Photoshop lets you copy from one image to another. Be aware, when cloning from another image, that it is rare that the tones and colors of both images will be identical, even if they were shot at nearly the same time. Some variations may also be introduced by scanning. Consequently, the copied area may not look like it belongs in the other image.

 To correct this, the copied image should be placed in a separate, *floating layer* above the original background. This lets you make corrections (such as Color Balance, Hue, Saturation, and Levels) only to the floating layer. For more about combining images (see Layers, page 75).

GRED SPAID
oiled Glove 5

emitransparent layers ere used to create this nage. Starting with cans of a postcard collected by his grandparents in the 1940s and a air of dirty gloves, Greg Spaid clone amped two different ersions of the postcard nto a layer above the loves. By making the ostcard layer semi-ansparent (see page 6) and by completely rasing parts of the ostcards, he ensured at the gloves can be early seen.

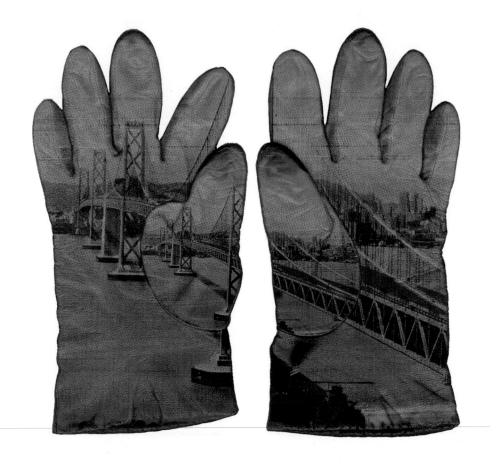

5

BEYOND BASIC IMAGE EDITING

Ten years ago artists could only have dreamed of the images that digital imaging makes possible today. With the growing popularity of digital imaging, features are being improved or added every year. This chapter will introduce several enhancements to the basic imaging procedures.

Curves control tones and colors. Curves are the most powerful tools for controlling brightness, contrast, and color balance. Using curves, almost any image can be made perfect.

Layers create composite images. Adobe Photoshop allows you to create images consisting of multiple layers. Layers are separate images that float above the background. You can make composite pictures by bringing together images from different sources.

Adjustment layers protect image data. A drawback to the early tools of digital imaging was that after many color corrections and contrast changes were performed on an image, data was lost and unwanted color artifacts would appear. Adjustment layers are a way to preserve all the color and tonal information in an image, no matter how much editing is done to it.

Masks and pens are advanced tools for making selections. They make it easier to create, edit, and reuse selections. With masks you can create complex selections and save them for later use. Pen tools let you draw a series of editable points and lines (a path) that can be saved in a palette and converted into a selection.

JILL GREENBERG Soles

In this advertisement for Toshiba consumer electronics, Jill Greenberg combined five separate images: the man, the TV and stereo speakers, the furniture, the picture on the TV, and a miniature model of the room.

The image was created in 1994 with an early version of Photoshop, one that did not have the layers feature (page 75). Without layers, each of the elements had to be positioned exactly, with no margin for error and no possibility of revision at a later time. Layers make creating composite images easier and less stressful.

Opposite ANNA ULLRICH Ticketholder

Contemporary photographers are creating composite images from the most unusual ingredients. Photographer Anna Ullrich says about this image, "The male figure is from a photograph I took of a taxidermist reaching into an embalmed orca whale's mouth. The landscape and faint image of a woman's face in the sky are appropriated photographs; the woman's face is incidentally from a photograph of my grandmother. The remaining imagery (the ticket, the tape measure, the cloth) are objects that I scanned on my flatbed scanner."

Curves

THE MOST POWERFUL WAY TO CONTROL TONES AND COLORS

A curve is a line on an interactive graph. When you move the line and change its shape (by clicking and dragging), the image's tones change interactively.

The Curves command changes brightness, contrast, and color balance more powerfully than the Levels and Color Balance commands. Levels lets you adjust only three points on the tonal scale: black, middle-gray, and white; Curves lets you adjust as many as 14 gray points, more than most images need. In addition to a curve for the combined colors there is a curve for each primary color. Thus Curves will do what the Color Balance command does—and do it with more power and control.

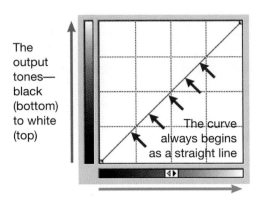

The output tones—black (bottom) to white (top)

The curve always begins as a straight line

The input tones—black (left) to white (right)

The curve as it appears before any editing. The curve is the straight line from the bottom left corner of the graph to the top right corner. Moving this line changes the tones of the image.

Understanding input vs. output is the key to using Curves. When the curve is moved, the brightness of the pixels changes. If the curve moves down, the image's pixels become darker. If the curve moves up the image becomes lighter.

Using a curve to correct too-dark tones

Bonnie Kamin

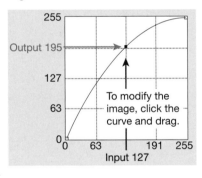

To modify the image, click the curve and drag.

Correction with Curves. Correcting this image with Curves is easy. Since the problem is that the midtones are too dark, the middle of the curve is dragged upwards (the midtones are in the middle). Wherever the curve is moved upwards, the tones become lighter.

Instant feedback. Photoshop shows you the effects on the image as the curve is being dragged if the Preview box is checked.

Before editing. This image has good white tones and black tones, but the midtones are too dark.

After editing. The middle tones are now clear and visible.

The Curves dialog box (below). There are two ways to open Curves. Image > Adjust > Curves opens the ordinary Curves control. Layer > New Adjustment Layer > Curves opens Curves in an adjustment layer (see page 79 for adjustment layers). Both types have the same interface and change the image's appearance in the same way.

The illustration shows the appearance of the Curves dialog box before any changes have been made to the curve.

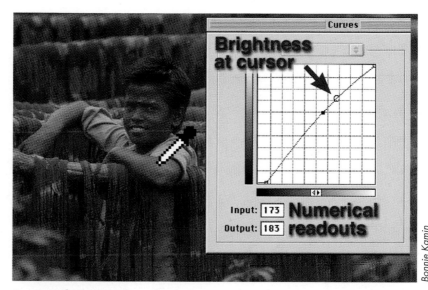

Bonnie Kamin

Getting information about the image. When you place the cursor in the image and hold down the mouse button, brightness information appears in the Curves dialog box.

- A circle appears on the curve, showing the brightness of the pixel under the cursor.

- The same information appears in numerical form below the curves graph. **Input** shows the brightness value (0 to 255) of the pixel before the curve was edited, and **Output** shows the pixel's brightness value after editing (the current value).

Moving the cursor with the mouse button held down lets you sample pixels from many places in the image. As the cursor glides around, the circle on the graph moves and the corresponding numbers change. The information you gain can help you decide how to place new points on the curve and which way to drag them to change their brightness.

The steepness of the curve controls the contrast of the image. Left, a steep curve makes an image contrasty.

Center, a flat curve gives the image low contrast. Curves can be drawn with many different levels of contrast.

At right, the image has contrasty shadows and highlights, but the midtones are flat.

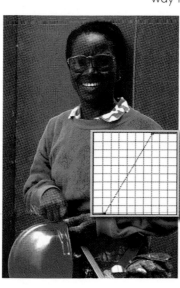

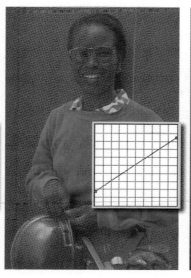

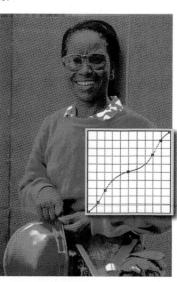

Bonnie Kamin

Curves
USING CURVES

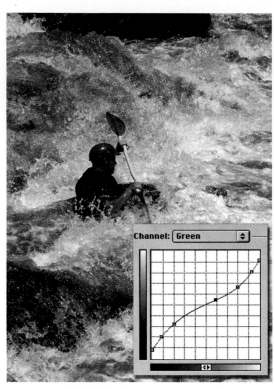

Color corrections with Curves. The Curves dialog has a curve for the combined colors plus individual curves for each color.

Here the green curve is used to correct a color problem. In the scanned image at left, green was overexposed in the bright areas and underexposed in the shadows, causing magenta shadows and greenish highlights.

At right, the green curve is raised in the shadows (which adds green) and lowered in the highlights (which subtracts green).

PROJECT

USING CURVES

The Curves command is the single most powerful correction tool available to digital image makers. This project will help you learn how Curves can affect every aspect of an image.

You will need a digitized color image with a full range of tones and colors. It should not be bigger than your screen at 100 percent magnification. You will be making many changes to see how the curve affects the image, so save a copy of the image in case you accidentally change the original permanently.

Procedure Use an adjustment layer to make your changes. Select Layer > New Adjustment Layer > Curves.

Be sure the Preview box is on (an x is in it) so that the entire image will change as you edit the curve. Before you begin changing the curve, click on different tones of the image. This makes a marker appear on the curve corresponding to the brightness of the pixel you clicked. Use this marker to learn about the relationship of the curve to the image.

Click on the curve to create points and drag them until you have created curves shaped like those pictured here. Try all these curve shapes plus as many others as you can imagine.

Are the places in the image in which the contrast appears flat associated with steep or flat parts of the curve? Notice how the contrast and color saturation of the image changes with each type of curve. Notice how small changes in the curve shape affect the image.

Next, experiment with changing the curve of each color, leaving the others unchanged. Then try giving each color a different curve. See how many color effects you can create.

How did you do? In this free-form project, you should have seen many radically different versions of the image. When the curve was steep, the image should have had high contrast. When the curve was flat, the image should have had low contrast. When the curve zigzagged up and down, the image should have shown posterization, a special effect in which the tones of the image seem unpredictably jumbled.

Layers

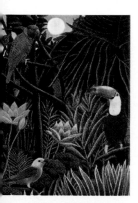

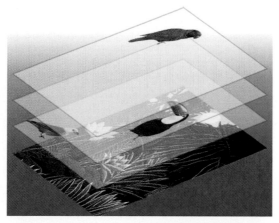

Using layers is the most reliable and quickest way to combine images. Layers are images within the image. They appear stacked on top of each other, like layers in a cake or cards in a deck. Unlike cards, images in layers don't all have to be the same size.

An image composed of layers is like a stack of glass plates with a photograph glued to each plate. The transparent areas outside each photograph let you view photographs on the layers below. You can move the pictures from side to side or change the order of pictures in the stack. Left, an image composed of layers. Right, how the layers would look if separated.

The image in a layer can be moved within the layer; you can reposition the image in each layer vertically and horizontally. In addition, the stacking order of layers can be changed. A layer can be shuffled up or down.

You can apply editing commands to just one layer. Each layer behaves like an independent image. Color balance, hue, saturation, levels, selections, and brush effects can be applied to a layer without affecting the other layers.

A layer can be made semitransparent so you can see through it. In addition, a layer mask (page 87) can be applied to a layer, letting you control the transparency more precisely— for example, a mask can make an image in a layer transparent or semitransparent in its center but opaque around its edges.

Adjustment layers are a different kind of layer. They don't contain images. Instead, they contain editing commands, such as Levels or Color Balance, that are applied to some or all of the image layers below them (see page 79).

Eye icon

Active layer

Paintbrush icon

Type layers are a third kind of layer. Type layers contain numbers and letters that appear in the image. Type layers can be reopened for editing.

In Adobe Photoshop, layers are stored in the Layers palette. To see the Layers palette, choose Window > Show Layers. The order of the the layers in the palette matches the top-to-bottom order of the layers in the image. The **eye icon** is present when a layer is visible. Making layers temporarily invisible is helpful in editing other layers.

Many types of editing can be done to only one layer at a time. You must click to **select the layer** you wish to edit; the selected layer is called the **active layer**. When a layer is active its name is in boldface, and its bar is highlighted. When a layer that contains an image is active it will also display a **paintbrush icon** beside its name bar. Adjustment layers and type layers don't contain images.

Layers
CREATING IMAGE LAYERS

How are image layers created? You can create an *image* layer by choosing Layer > New Layer or by choosing New Layer from the Layers palette's options menu. Photoshop also automatically creates an image layer every time you paste one image into another. When you use the type tool to place text in the image, each text entry creates its own layer.

Naming layers. Whenever you create a layer from a menu or palette you'll be asked to name it. However, if you paste a picture into an image the layer will be named automatically. It's easier to keep track of layers when they have descriptive names ("Red Toyota"). You can rename a layer by clicking on its thumbnail image in the Layers palette (Photoshop 5.5 or earlier) or by clicking the Layers palette's options button and clicking Layer Properties (Photoshop 6).

LISA JOHNSTON *uluru*

Semitransparent layers can create strong visual effects. When you set the opacity of a layer to less than 100 percent, it becomes semitransparent and the layers beneath it can be seen. In Lisa Johnston's image "uluru" (right), the image is composed of five layers. Three of the layers are semiopaque, but each has a different percentage of opacity. The topmost layer, a barely noticeable series of rings centered on the red mountain, is only 10 percent opaque.

Image layer options. Clicking an image layer's thumbnail image in the Layers palette (right) opens a dialog (far right) in which you can specify many effects. The Blending Option **Opacity** is often the most important effect; it allows you to make the image in the layer opaque or semitransparent. Other Blending Options, like **Blend If,** permit you to make parts of the layer transparent while leaving the rest opaque. For example, Blend If lets you make only the lightest pixels of the layer opaque. Wherever its pixels are dark, they are made transparent and the underlying image shows through. Blend If also permits separate opacity effects for each primary color.

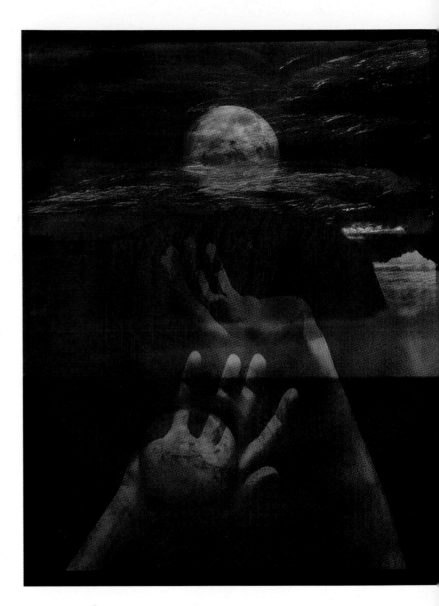

STEVEN BLISS
Nature Boy (State II)

Attention to technical details can turn a seemingly incompatible mix of ingredients into a believable image. Creating Steven Bliss's allegories of boyhood in a "normal" American town requires attention to scale, lighting, contrast, and color saturation.

In addition to placing photographs and digital paintings in layers, he carefully paints shadows on the background layers to anchor the objects in the space.

Matching color balance and saturation is important to making realistic collages. At right, two layers clash with their background.

One layer has a cyan-blue color cast, which can be corrected with the Image > Adjust > Color Balance command (or with Levels or Curves).

The other layer is balanced, but it has too much color saturation. The Saturation command in Image > Adjust > Hue/ Saturation could remedy this.

When images are pasted into other images, they often clash with their new surroundings. Something about them looks wrong. If realism is your goal, an image blended into a background must match the background in several ways.

Scale and resolution. An object's size must harmonize with its background. If an object is placed anywhere that gives clues as to its spatial relationship with the background, it is easy to see if it looks too large or too small. It's also easy to see a clash between an object and the background if they differ in sharpness or graininess.

A conflict of perspective can occur when two images taken by lenses of different focal length are combined. For example, imagine two people shown talking face to face. The result will look peculiar if one person was photographed with a wide-angle lens while the other was photographed with a telephoto lens.

The quality of the light on an object can make that object look like it doesn't belong in the picture. Sunlight casts shadows and creates sharp boundaries between the sunlit and shadowed parts of an object, while light from a cloudy sky is smooth and without shadows. The direction of light is important, too; if the background light appears to come from the right, it will be distracting when the light on a foreground object comes from the left. Contrast often needs to be adjusted if an object is to blend into the background; it's distracting when several shadows don't look equally dark. Note that indoor light often comes from several directions; each light source may have a different color tint.

Layers
MANAGING LAYERS

Layers are very useful, but an image with many layers can use up all of your computer's RAM. This will slow your computer down and make it difficult for you to work productively. Images with fewer layers also print more quickly; in some cases an image with too many layers may fail to print or cause the computer to freeze.

Speed up your computer by reducing the number of layers. You can *merge* layers together. In Photoshop the Layers menu contains the Merge commands.

Layer > Merge Down merges the active layer into the layer shown below it in the Layers palette.

Layer > Merge Visible merges all the visible layers (those with their eye icons visible in the Layers palette). The active layer must be visible or this command will not work.

Layer > Flatten Image merges all the layers into one layer.

Layers are saved only when the file is saved in Photoshop format. Layers are not saved in TIFF and JPEG formats. Save an archival copy of your image in Photoshop format if you believe you may work on it again in the future.

Photonica

LISA POWERS
Untitled

Faded layers. Assigned to create a magazine illustration that depicts how media changes our way of experiencing the world, Powers decided to create a highly layered black-and-white image. To make the edges of the head gradually fade semitransparently into the rest of the image, she attached a mask to the head's layer (page 87).

PROJECT

CREATING AN EXTENDED FAMILY

You will need digitized versions of several pictures of your family or friends. Your artistic goal is to combine people from the separate images so they seem to belong together or else to make the image obviously artificial but acceptably plausible. Before you begin, see Making a Composite Image Step by Step on page 80.

Procedure Using selection tools, copy images of people (with or without their surroundings) from two or more sources and paste them into a third image. Consider whether you want realism or an artificial look. Realism requires much more work.

You'll be combining images from several sources, so you'll need to plan ahead to ensure that the people's images are the right size in relation to each other.

Each image you paste creates a new layer, so you can apply color and tonal corrections to it. You can also move the layer's image until you have a satisfactory composition.

Since you will have more than one image open on the computer, be sure you don't make such large files that your computer runs out of memory. If you do, use one of the Layer > Merge . . . commands.

How did you do? This is a freeform exercise, but it will help you discover whether you know how to change the size of images, crop and trim them, paste them into an image, and adjust the tones and colors of each individual layer. If your composition works, you will create an artificial but interesting group portrait.

Adjustment Layers
PREVENTING COLOR BANDING AND DATA LOSS

 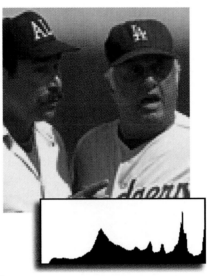

Bonnie Kamin

Without adjustment layers, colors can show bands. Left, an image and its histogram. This image was previously edited with Curves, Color Balance, Hue, and Saturation commands. Banding is visible; the tonal gradation has an abrupt staircase appearance instead of a smooth, normal transition. A histogram can be used to diagnose banding. This one has gaps that look like the teeth of a comb. These gaps represent brightness levels where data was lost during editing.

At right is the Levels dialog box for an image that has had the same editing done with adjustment layers. The image has smooth gradations, and all of its original tones are present in the histogram.

Adjustment layers appear in the Layers palette. Instead of displaying a paintbrush icon to the left of its name, an adjustment layer displays an icon that indicates a "mask" (see masks, page 84).

An adjustment layer normally affects all of the layers beneath it. However, if you want to limit its effects, you can group it with one layer (or with several layers) using the command Layer > Group with Previous. Layers beneath the grouped layers are not affected by the adjustment layer.

Normally, as you edit an image its data is altered forever. For example, if you change gray pixels into pure whites, the changed pixels are given new values of red 255, green 255, and blue 255. If you cannot Undo the change, all records of the original values are lost forever. Often, after a series of edits, the original data is so altered that only a few thousand of the original 16 million colors remain. The result is that banding is visible (see left).

Adjustment layers solve banding problems. Adjustment layers (Layer > New > Adjustment Layer) allow you to edit many aspects of the image without ever changing the original pixels. An adjustment layer contains no image, just commands that alter tones and colors in the layer(s) beneath it. The adjustments never alter the original pixels. As a result, an adjustment layer's effects are permanently "undoable," even if you reopen the image years later. Note: the History palette in Photoshop 5 (and later) lets you undo an almost unlimited number of changes, but all histories are erased each time you close the image. You cannot undo anything when you reopen the image.

There are limits. Not all image editing can be done in adjustment layers, but many important ones can: Levels, Curves, Color Balance, and Hue/ Saturation. Certain special effects, like drop shadows and type effects, can also be applied in adjustment layers. Unfortunately, at this time adjustment layers cannot be used to change image resolution or to apply filters like Unsharp Mask.

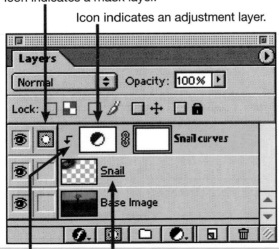

Icon indicates a mask layer.

Icon indicates an adjustment layer.

Underlined layer name indicates that the layer is grouped with the one above it.

Indented thumbnail with downward arrow indicates that this layer is grouped with the one below.

Making a Composite Image Step by Step

Plan your image. Before starting, visualize your final image and decide which component images you will use. Don't plan an image that's too big for your computer or its memory. Remember that by opening several images at the same time and having many layers in an image you will increase the demands on your computer.

1. Sketch what you visualized. Draw a picture of your background image and place paper cutouts of each component layer over it. Will the image components work together visually? Will they create an interesting image? Make changes in size and placement until you have a good design. Sketching on paper is faster than using a computer to sketch a design. Working on paper lets you try out ideas more quickly.

2. Inspect each component. Examine the component images together at the same magnification. Do the components and the background have compatible contrast, color balance, and saturation? If you plan a realistic image, do the components have similar lighting qualities (hard-edged light or soft light), and is the direction of the light the same? If the light is incompatible, you may need to choose other components.

Examine each component to see how difficult it will be to remove it from its background. If the selection process will take too much time you may wish to use another component image.

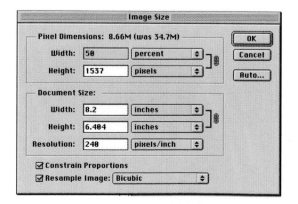

3. Adjust all of the components. Compare your sketch with the components on the screen. Will you need to resample any of the components (page 40) so that they all have the right size? Components that are too large can be scaled down, but components that are too small may need to be rescanned at a higher resolution. If you need to make scans for any missing components, be sure their pixel resolutions are compatible.

When reducing the size, use the Image > Image Size command. Checkmark the Resample Image box and select Bicubic from its pull-down menu. Bicubic resampling retains the highest image quality, although it takes more time than other options.

Adjust the contrast, color balance, and saturation of all of the components. You will get a chance to fine-tune them later, so this adjustment can be approximate.

4. Select a component and copy it. The right selection process will make component images blend into the background image more easily. Almost all selection procedures are easier and more precise if you zoom the monitor image to 200 to 400 percent magnification.

- If the colors of the background image and the component image are identical, select the area you wish to copy with the lasso tool. Feather the selection and draw the selection far enough away from the subject so that none of it is in the feathered area.

- If the background must be removed around the edges of the subject, try selecting the background with the magic wand or the Color Range command. Then use Selection > Inverse command to deselect the background and select the subject.

- If the background must be removed, but the edges of the subject are out of focus or difficult to work with (such as hair), make selections with a pen tool (page 82) because pens are precise and allow selection boundaries to be changed later if they are not perfect. Many experienced users prefer to use masking (page 84), another process for creating editable selections.

- Dedicated masking software, like Extensis Mask Pro™, works in conjunction with Adobe Photoshop. These auxiliary programs offer sophisticated tools that simplify creating selections.

After making the selection, save the selection (page 86) in case you need to redo it.

5. Copy the selection and paste it into the background image. Use the move tool (in the main tool palette) to position the new image over the background. Determine how well the new image blends in. If too much of the old background remains around its fringes, you might try erasing the unwanted fringe with a tiny brush. If this doesn't work, you'll need to redo the selection process.

Evaluate the layer's overall quality. Is the image on the new layer the right size? If it is too large you can scale it (Edit > Transform > Scale), but if it's too small you'll need a larger original. Are the contrast, color balance, and saturation correct? You can use a grouped adjustment layer (page 87) to correct the contrast and color imperfections of any one of your component images.

Repeat steps 4 and 5 for each of the images you add.

6. If you flatten the final image (Layer > Flatten Image) to make it print faster, keep a copy of the original with all of its layers, in case you need to edit it again.

Advanced Selection Techniques
DRAWING SELECTIONS WITH THE PEN TOOL

The pen tool. There are times when large selections should be made by outlining them with a freehand-drawing tool. Other outlining tools, like the lasso (page 57) are effective and extremely precise, but for drawing large selections they are cumbersome. The pen tool combines the advantages of the outlining tools with greater speed and flexibility.

A pen tool lets you draw editable selection boundaries. The pen tool creates a series of automatically connected lines (a "path") that can be edited after they are drawn. A path can be moved, stretched, and curved. The lines of a path are so flexible that they can be made to curve around and enclose complex shapes. If the path's two ends are joined together to form a complete enclosure, the entire path can later be turned into an ordinary selection, which can be further edited with any of the regular selection-modifying commands.

Creating a path does not automatically create a selection; you must convert the path into a selection with a command (see opposite).

Paths are not based on pixels; they are vector objects. Vector objects are a class of computer graphics unrelated to pixels. Pixels are arranged in rows and columns while vector objects are mathematical descriptions of the location of points and the lines connecting them. Of course, you don't see the mathematical equations; only the lines created by the equations are visible on the monitor. These equations create curved lines, which are called Bezier curves. Because a Bezier curve is only a set of numbers, it takes up less memory and disk storage than a memory-hungry bitmap.

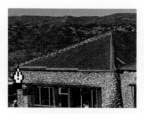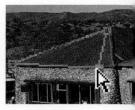

Drawing straight lines. Left, to draw a straight line, select the pen tool and place an anchor point by clicking on the image. Center, click repeatedly to place additional anchor points; this creates anchor points with straight lines between them. Right, the anchor points can be dragged with a path-dragging tool to change the shape of the path.

To create a curved line that follows the curved shape in the image, click to create the first anchor point and hold the mouse button down while dragging the cursor in the direction you want the curve to go. Two odd-looking direction lines with handles at their ends will grow out of the first anchor point. One of them will follow the dragged cursor (1). Ignore them for the moment.

After dragging them a short distance, let go of the mouse button (unclick) and move the cursor to wherever you wish to place the second anchor point (2). It is important not to place the second anchor on the same spot you unclicked. Click again and hold down the mouse button.

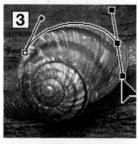

Without unclicking the mouse button, continue dragging. Notice that a curve is drawn between the first two anchor points as you drag the cursor away from the second anchor point (3). Drag the cursor so that the curve being drawn between anchor points one and two is placed where you want it to be. Unclick when the curved line between the anchor points is the shape you desire.

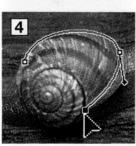

(4) Click in a third place to create the third anchor point, and drag to create the desired curve between anchor point two and the new point.

Repeat this procedure until you have drawn the entire curve. The key to curves is that by dragging the cursor away from the last anchor point you created, you create the curved line between that anchor point and the previous one.

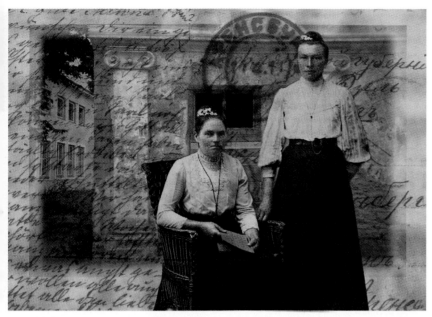

JACQUELYN LEEBRICK Postcards from Estonia: Young Women/ Saarma

Pen tools can be the most exact way to outline complex selections. Jacquelyn Leebrick needed to exactly outline a selection around the two women in an image she scanned from a turn-of-the century Estonian postcard. The pen tools make it possible to create editable and correctable selections.

This means that an image file composed of a picture plus a set of paths will be smaller than the same picture plus saved bitmapped selections. (Selections are saved as alpha channels; see page 68.)

Paths have other uses. Although making selections is the most useful thing photographers can do with paths, paths have other software abilities. These can be directly filled with a color from the palette, or they can be turned into a colored lines of variable widths.

In Adobe Photoshop a path can be converted into a clipping path. When an image that contains a clipping path is exported to (exported essentially means pasted into) another software program such as Adobe Illustrator, the portions of the image outside the clipping path are cropped out; they are invisible (transparent) in the other program. For example if you create a clipping path around one person in a group photograph and then export the whole image to Adobe Illustrator, only the clipped person is visible.

Converting paths to selections. Once you have completed the drawing of an enclosed path you can choose the command Make Selection from the Paths palette's pop-up menu. This converts the path into an ordinary selection. All the commands that can be applied to an ordinary selection (such as Feather or Shrink) can now be applied to the newly created selection.

The original path remains for further use; it is not destroyed when it is used to create a selection. To save the path permanently, choose the item Save Path from the Paths palette's pop-up menu.

Advanced Selection Techniques
USING MASKS TO CREATE SELECTIONS

Masks are the most advanced way to create selections. Think of a mask as a sheet of plastic that lies on top of an image. Wherever you cut holes in the plastic you can edit the colors and tones of the image beneath, but wherever the plastic is solid nothing can change to the image—the image is *masked*.

One advantage of masks is *variable* density. While ordinary selections have feathered or anti-aliased edges, a mask lets you make *any* part of a selection opaque, transparent, or in between. Wherever a mask is transparent you can edit the image normally. Wherever a mask has partial density, the editing effects are partial. For example, if you increase contrast, the image under the transparent areas of the mask shows high contrast but the image under the semi-transparent areas of the mask shows only a smaller increase in contrast.

Masks are not selections; additional commands are used to create selections from masks. For example, in the Channels palette (page 86), clicking the "Load channel as selection" icon turns the currently highlighted channel into a selection. (A channel is the place where a mask is permanently stored; see pages 86, 88–89.)

Seeing through a mask. A mask can be easier to use than an ordinary selection because of its visibility. Ordinary selections are visible because their edges are marked by a moving marquee (the marching ants). But if it's a feathered selection, the marquee doesn't show exactly where its edges are. A mask is better; you can see all of it. A mask appears on the monitor as a blanket of color over the image. The colored blanket is most dense where the mask is fully opaque and is transparent where the

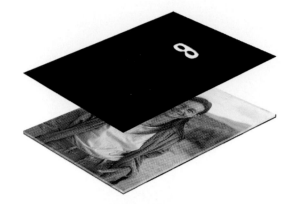

Masks are like coverings placed over images. Masks restrict the editing done to the image beneath the mask. In some ways a mask is like stencil.

NOTE: Before a mask can be used to edit an image, it must be converted into a selection (see example below).

Problem: to remove the figure and paste it into another image. Top left, the figure with a selection drawn around it. The hair is a problem, however, and is only roughly selected. More work must be done on the hair. Top right, the selection is turned into a mask with the command Select > Save Selection . . . The mask is shown as light red where is it opaque and is transparent over the former selection.

Below, left, a close-up. To improve the hair, just the mask is edited by painting. Delicate detail can be preserved with semitransparent brushstrokes. Below right, after the mask was painted, the mask was turned into a selection with the command Select > Load Selection . . . The selected area was then copied and pasted into another image, which appears behind the figure's hair.

Using a mask created from an image to create special effects in another image.

1 and 2. A landscape and a grayscale image of a dancer. The dancer's image will be used to create a ghostly image in the landscape.

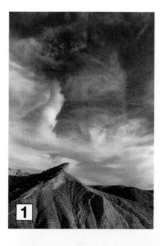

Bonnie Kamin

3. A channel (see page 86) is created in the landscape. It is named "ghost image."

The dancer's image is selected by outlining then copied and pasted into the landscape's new channel. This creates a mask **(4)** containing an image of the dancer.

5. The "ghost image" mask is loaded as a selection in the landscape.

6. Two adjustment layers are created. They affect only the selection (the ghostly image of the dancer). The adjustment layers are Hue/Saturation and Curves. The adjustments create the colorful, ghostly image in the sky. Note: Step five is performed twice, once for each adjustment layer. The adjustment layers are moved slightly away from each other so their effects are not exactly superimposed.

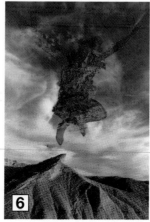

mask is transparent. You choose both the color of the mask and how opaque you want it to appear on the monitor (usually you don't want a mask to be so opaque that you can't see the image beneath it). You can also temporarily make the mask invisible if it blocks your view of what you're doing.

Adobe Photoshop treats masks as grayscale (8-bit) images. This has significant consequences. Because the software treats masks like images, you can edit them like images. This means you can use a brush to paint on a mask, making the mask either more opaque (blacker) or more transparent (whiter).

Because masks are treated as images you can also paste shapes and other images into masks. For example, you can put type into a mask; the shapes of the letters can then be transformed into colors or effects. You can paste images into masks (but only 8-bit grayscale images, see left). In fact, because a mask is a grayscale image, you can apply any of the non-color editing techniques discussed in chapters 4 and 5.

Selections can also be turned into masks. Clicking the "Save Selection as Channel" icon in the Channels palette turns the selection into a mask. *Why do this?* Most complex selections start with a simple selection, as you might make with the lasso tool or the magic wand; by turning them into masks you can edit them more precisely. Finally they are turned back into selections. This may sound roundabout, but it is a powerful technique. For example, it is helpful when creating extremely complex selections, such as one around someone's hair.

Alpha Channels

WHERE MASKS ARE STORED

Masks are stored in the Channels palette where they are called **alpha channels.** Because color channels are also found in the Channels palette, it is important to know that the two have little in common. Color channels contain the color information about an image (see page 88). The information in color channels is part of the image. Color channels are visible in the image. However, masks stored in alpha channels are not part of the image; they are never seen in the image. Alpha channels are merely storage areas for masks—nothing more—and masks are just editing tools that help create selections. You never see the mask itself in the completed image.

Alpha channels are a part of the image's file; they may remain when the image is saved. Their disadvantage is that they increase the file size. For example, an RGB image file that is three megabytes can expand to four megabytes with one alpha channel.

When your image editing is complete, you may have no reason to keep them, so you can drag the alpha channels to the trash can in the Channels palette. Don't discard them if you expect to rework the image later. If you want to keep them, save your files in Adobe Photoshop format. Some formats like JPEG can't save alpha channels.

Note: While discarding alpha channels, be careful not to unintentionally discard masks attached to layers (page 87). Masks whose names appear in *italics* in the Channels palette are not alpha channels. It is also possible to discard the color channels. Normally, however, this will ruin the color balance.

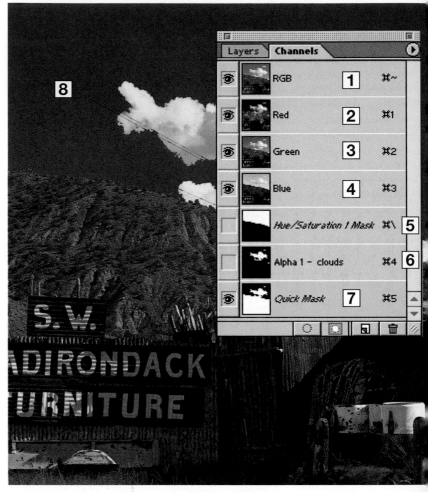

Three types of channels

1–4. Color channels. The Red, Green, and Blue channels and the RGB (composite) channel are part of every RGB image (see page 88).

5. Adjustment layer masks (page 87) appear when corresponding adjustment layers are selected in the Layers palette. Only one adjustment layer mask is displayed at any time, no matter how many adjustment layers the image contains.

6. Alpha channels. The channel named Alpha 1 Darken clouds (named by the photographer) is a mask that was created to lighten the dark tones in the trees.

7. Quick Mask. There is a second type of alpha channel on this palette, a Quick Mask. Quick Masks are convenient, but temporary alpha channels in Adobe Photoshop. They are created by clicking the Quick Mask Mode icon on the tool bar (not shown). You can convert a Quick Mask into an alpha channel by loading it and saving it, but you can have only one Quick Mask at a time.

8. The Quick Mask is the red-tinted area covering the image. It is visible in the image window because its eye icon is switched on. Note that the eye icons of the adjustment layer mask and the alpha channel are switched off. Masks whose eye icons are not visible cannot be seen in the image window.

Editing an image layer's mask. Like all masks, a layer mask can be edited with painting tools. In this example, an image layer has a mask that is transparent at first.

At top right, the background and a layer (with a figure) floating on top of it.

Center right, the way the Layers palette appears after the completion of the command Layer > Add Layer Mask > Reveal All. A thumbnail image of the mask appears next to the thumbnail image of the layer's image. Between them is an icon depicting links in a chain, signifying that the mask and image are linked together.

Bottom right, the effects of painting on the layer with black. Painting adds density to the mask. This hides the image in the layer and lets the background show through. If you prefer to see the mask while painting, you can make it appear by clicking on the mask's eye icon in the Channels palette.

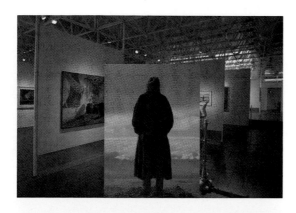

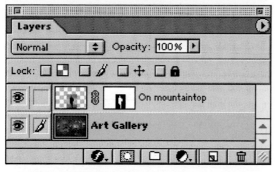

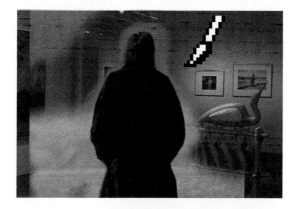

A layer mask is a mask attached to a layer. Layer masks are useful because each mask only affects what's on the layer; the rest of the image is untouched. Two types of layer masks are useful to photographers.

Image layer masks. A layer mask can make part of an image on its layer invisible: Wherever the layer mask has full density (black), the image is hidden, and wherever the layer mask is transparent the image is visible. A partially erased mask makes the layer's image partially visible.

Outlining an object is a common use for an image layer mask. By painting the mask black around the object, you'll make the layer around the object disappear. First, create a mask by choosing Layer > Add Layer Mask > Reveal All. As a result of choosing Reveal All, a transparent mask is created. When you paint black onto the mask, that part of the image becomes invisible. This is a forgiving procedure; if you make an error while painting, you can erase and repaint.

Adjustment layer masks. Creating an adjustment layer creates a transparent mask in the Channels palette (see page 86 for how masks are stored). Whenever the adjustment layer is active in the Layers palette, its mask becomes visible in the Channels palette. When you paint on the mask, the paint masks the adjustment layer; the effects of the adjustment layer are eliminated (see below).

Bonnie Kamin

Masking an adjustment layer. A mask attached to an adjustment layer controls the intensity of the layer's effects. At far left is an image in which an adjustment layer was used to decrease contrast until the image was almost a featureless gray. However, the mask (left) protected the central area of the image and preserved its normal contrast.

Color Channels
WHERE COLOR INFORMATION IS STORED

Color channels are where information about colors is stored. An RGB image has three color channels: red, green, and blue. A CMYK image has four color channels. Each color channel is a grayscale image with 256 brightness levels. Each is an individual image, just as the three layers in color film are individual images. Like the three layers in film, color channels appear blended together when the image is viewed normally. However, editing software can also display each channel separately or in combination with one or more of the other channels.

What's the difference between a layer and a color channel? Because color channels make using Photoshop more complex, it's important to know the difference between a layer and a color channel.

- A layer is an individual, full-color image. Layers can be stacked to create a composite image.

- Color channels are the color components of a layer. Each RGB layer has three color channels.

- When you edit color channels, you edit the color channels of one layer at a time. The active layer (the one selected in the Layers palette) is the only layer on which the color channel editing is happening.

Sometimes it helps to edit only one color channel. On occasion, one channel is less sharp than the others, or it may appear too grainy. To fix this, you might remove grain in one color channel by blurring it with a filter, while you sharpen another color channel with a different filter (see Digial Filters for Special Effects, page 91).

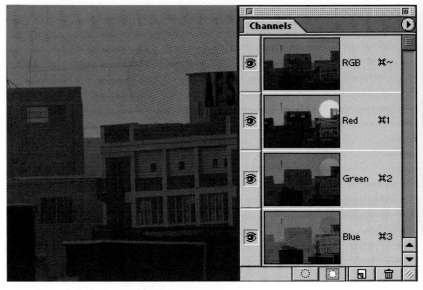

An RGB image has three color channels. Individual color channels are displayed as thumbnail images in the Channels palette (above). The composite of all channels is labeled RGB. When the eye icon is present beside the RGB channel's thumbnail, the image is displayed in full color in the main image window. It's best to view the individual color channel's thumbnail images in black and white (instead of color) because they are easier to compare with each other.

Color channels can be viewed individually in the main image window by making the other channels invisible. Channels are turned on or off by clicking their eye icons. Below, only the blue channel is visible (as a black-and-white image) in the main image window. The composite channel and the green and blue channels have been turned off (their eye icons are not visible).

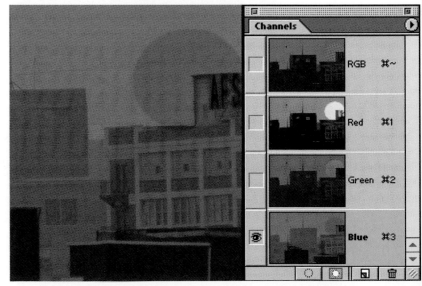

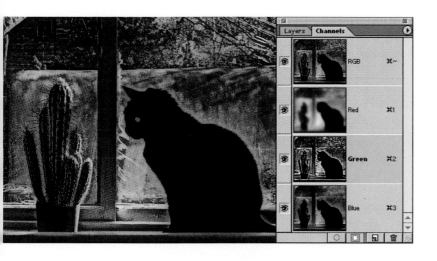

Special effects with color channels. To create a halo effect, a very strong Glow filter (Filter > Distort > Diffuse Glow) was applied to the red channel. Then an Unsharp Mask (Filter > Sharpen > Unsharp Mask) was applied to the green channel (see Digital Filters for Special Effects page 91).

In order to edit only one channel, you must select it in the channel palette. Note that the Green channel's name is highlighted; highlighting indicates that the channel is active. Since it's normal for *all* color channels to be active at once, you must individually deselect the others.

KATRIN EISMANN
Self-portrait

Using color channels to create image features. Eismann's self-portrait was created with a flatbed scanner. The scanner made separate exposures for red, green, and blue, and the editing software converted the three exposures into color channels. During the three exposures Eismann kept her face very still while moving her hand to different positions to create an image of many hands.

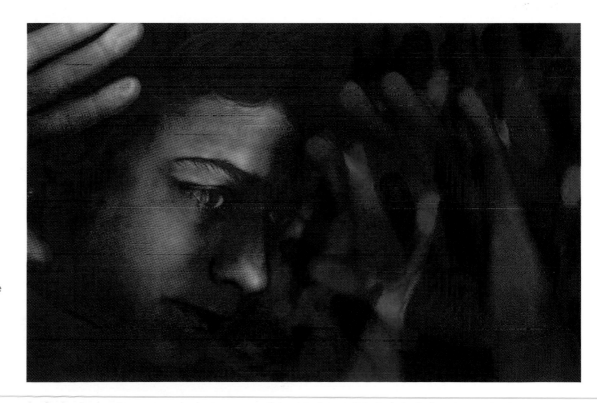

Troubleshooting

KEEPING TRACK OF LAYERS, CHANNELS, AND MASKS

With power comes complexity. Selections, layers, channels, and masks make imaging software the tool of choice for thousands of artists, but such power brings complexity and the potential for confusion. You can be stumped when the software does not do what you expect it to do. At right is a very basic list of steps to take when things go wrong. As your experience in digital imaging grows, develop a personal troubleshooting checklist by adding to this one.

Can you solve this puzzle?

If you try to edit layer 3, the active layer, why will nothing appear to happen?

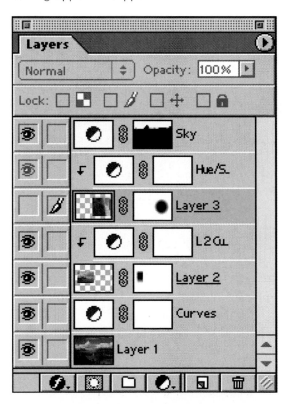

Answer: Layer 3 is invisible; its eye icon is switched off. Your edits are occurring, but you just can't see them!

When something goes wrong, stop and think. Make sure that you are editing where you think you are in the correct image, in the correct (and visible) layer and in the correct (and visible) channel.

SOME BASIC TROUBLESHOOTING PROCEDURES

1. The editing software stops working. Try closing a palette to see if the whole computer is frozen.

- If a palette won't close, try switching from the imaging software to Microsoft Windows or the Macintosh Finder. If you can do this, the computer is OK, and your problem is with the imaging software.

- Is your image so large that the computer is still working on your last command? If not, you may need to exit and restart the imaging software.

- If the entire computer is frozen, restart the computer or get help from a lab technician.

2. If your last command did not work the way you think it should have, stop. Do not issue new commands, as you could accidentally edit the image. As a precaution, use the software's Undo command to undo your last known successful command. Does Undo work the way you expect? If it does, cancel the Undo command.

- If Undo does not work, something you weren't aware of happened *after* your last successful command. Don't cancel the Undo command, as it might have undone something you don't want. Either way, go to step 3.

3. If you still aren't getting the results you expect, consider some common reasons that this can happen.

- Are you are trying to edit outside the selection? See "When Your Software Commands Quit Working," on page 56. Also, if more than one image is open, are you confused about which image is active?

- Are you trying to edit the wrong layer? Only the active layer can be edited, but it is possible for the active layer to be invisible, so your edits *are* happening but you can't see them happening! Be sure that you have the desired layer active and that it is visible.

- Are you trying to edit a channel or mask that isn't visible or isn't active? It is possible for the active channel to be invisible, so your edits are happening but you can't see them happening. Be sure that the channel you want to edit is active and visible. Also, you may have the right channel, but you may be working in the wrong layer.

Sometimes a command you want to use is grayed out or is missing from the menu. Some commands are not available at certain times. For example, when an *adjustment* layer is active, many menu options are grayed out. They become available only when an *image* layer is active. Problems like this are best solved by reading the software's manual.

Are you trying to save a file but it won't save? You may be trying to save the file in a format that won't accept the features in your image. For example, you can't save a layered image in JPEG format. You may be trying to save the file to a disk that can't accept new files, such as a locked disk or a CD-ROM.

Digital Filters for Special Effects

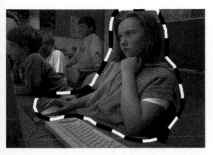

Bonnie Kamin

Blurring the image around the subject. The subject is outlined with a feathered selection tool. Then Select > Inverse selects the area *around* the subject. The filter Motion Blur (Filter > Blur > Motion Blur) blurs the selection horizontally, creating an illusion of motion. The direction of the blur is chosen by the photographer, and the amount of blurring is set by numerical input.

Removing dust spots and scratches

Step 1. Apply the Dust and Scratches filter to the entire image with the command Filter > Noise > Dust and Scratches.

Step 2. Top left, take a "snapshot" of the dust-free image. A snapshot is a copy of the image. Snapshots are stored in the History palette. Open the History palette with the command WIndow > Show History. From the History palette's pop-up menu, select the command New Snapshot. Name the snapshot (for example, "Dust-free version").

Step 3. Second from top, you will see *two* snapshots in the History palette. Click the original, dusty image to make it active. Active means that it is the version that is being edited. The image reverts to the way it was before you applied the dust and scratches filter.

Step 4. Third from top, in the history palette, click to the left of the dust-free version of the image to make its brush icon visible, indicating that when you paint on the image with the history brush (see below), the dust-free version will be copied by the brush, as though the brush was the clone stamp tool.

Step 5. Select the history brush tool from the Tool bar palette. The history brush is a special brush that paints from one version of an image (the source version) to another (the active version). It's like cloning from one image to another.

Step 6. Bottom, use the history brush to paint over dust spots in the original (dusty) version of the image. The dust-free version will be painted in.

Software filters are like camera filters—they create special effects. Hundreds of digital filters compatible with Adobe Photoshop are available from software companies. It is even possible for people with a limited knowledge of software programming to create their own filters.

Software filters, like camera filters, can be gimmicks that distract you from careful seeing and creative thinking. Most filters are useful primarily if you want to transform photographs into photo-illustrations.

A few filters are useful if you want the image to look purely photographic. Unsharp Mask (page 98) makes focus look sharper. Blur filters (Filter > Blur > . . .) reduce focus sharpness. Noise filters (Filter > Noise > . . .) increase or decrease the appearance of graininess in images. Digital graininess is the result of film grain or electronic noise in the scanner. Some filters and tools (such as blur filters or the smudge tool) eliminate the graininess, with the undesirable side effect that the blurred areas appear artificially smooth compared to the rest of the image. A noise filter corrects this by restoring a grainy appearance to the blurred areas. Select the blurred areas before filtering.

The Dust and Scratches filter removes defects from an image, but it has the unwanted side effect of blurring the image. However, there is a way to apply it only to the scratched and dusty parts without blurring the image. See left for the details of this important technique.

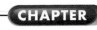

CHAPTER 6

DIGITAL PRINTING AND ELECTRONIC PUBLISHING

You can share your work with thousands of people via the Internet and multimedia CD-ROMs. Mass communication with these new media is less expensive than traditional forms of printed distribution. But even as the new media grow, digital technology is improving the old methods of presentation; new types of computer printers make it possible to print digital color images on paper quickly and inexpensively.

Despite these technological advances, technical problems remain. How can you be sure that your audience will see the same colors and tonal values that you saw on your monitor? Unless people view your work on your computer's monitor, the image will always look different. This chapter examines ways to reproduce your images accurately. You'll learn how to get good colors from printing devices, even if your monitor isn't new or well calibrated.

If you plan to distribute your work electronically, you'll put your images on a web site or into multimedia presentation software for use on a CD-ROM. You'll need to know how to adjust your monitor to match industry standards. You'll also need to know how to put your work into file formats that can be read by Web browsers and multimedia software.

Printing on film and photographic paper. Another way to print a digital file is with a film recorder. Film recorders produce color transparencies or negatives from which traditional darkroom prints can be made. An even more direct path uses specialized computer printers that expose and develop photographic paper.

Opposite Darkroom printing vs. digital printing. Exceptional tonal and color qualities are possible with digital printing. Left, a darkroom print made by a custom photographic laboratory. Right, a digital print made with an inexpensive Epson Photo Stylus printer. The digital image was made from a Kodak PhotoCD scan that was enhanced with Adobe Photoshop.

This 1997 image of comet Hale-Bopp was taken on 35mm color negative film with an ordinary 50mm lens. A small telescope kept the camera pointed during the three-minute exposure.

Making Your Prints Match the Monitor
GAMUTS AND COLOR MANAGEMENT

Prints don't look exactly like the image on the monitor. And just as in darkroom printing, a great deal of time and money is wasted by photographers who make print after print until the image is perfect. Software like Adobe Gamma (page 46) is very helpful, but it only begins to solve some parts of the problem of getting prints to match the monitor.

The real problem is that a computer does not "know" two important pieces of information: how accurately your monitor reproduces colors and how accurately your printer reproduces colors. All a computer does is to send instructions to the monitor and to the printer about what color each pixel *should* be. A computer has no way to get *feedback* about how each device actually illuminates screen phosphors or mixes inks. As a result, when the monitor and the printer have different "ideas" about what the color "red 220, green 164, blue 139" looks like, the print will not look like the image on the screen. Even when the monitor is calibrated with Adobe Gamma software, the inks and dyes used by printers rarely form colors identical to the colors of a monitor (see "Human Vision and Color Gamuts").

Human Vision and Color Gamuts

The human eye sees more colors than machines can reproduce. The term **gamut** is used to describe all the colors that a particular machine (a monitor or an inkjet printer, for example) can reproduce.

Above, the entire colored area represents the human "color space " (gamut), all the colors the eye can see. The area inside the line represents the colors that a computer monitor can reproduce.

Here, the area inside the line shows the gamut that an inkjet printer can reproduce with CMYK inks.

Here, the area inside the line shows the gamut that the CMYK inks used in offset printing (like this book) can reproduce.

Since these illustrations are printed using offset CMYK inks, they can only symbolically represent the full range of color visible to the human eye.

Some labs do not use color management yet. If your lab doesn't use it, you'll need shortcuts so you can create finished prints with fewer test prints. The procedure here creates such a shortcut, a reusable software file that adjusts your monitor to match your printer.

a. Before you print, find out if the printer you intend to use makes better prints when you edit in RGB mode or CMYK mode (see page 96).

b. Use Adobe Gamma to calibrate the monitor. It's important to do this if you work in a computer lab; a previous user may have changed the monitor's settings. For prints, set the gamma to a value of 1.8.

c. Edit a test image typical of the kinds you ordinarily make. Be sure it has a variety of colors and tones. Make it look good on the monitor. Print it.

d. Compare the print and the monitor image. Does the print have a color bias and if so, which colors? Are any print colors over- or undersaturated? Are the print's midtones and shadows too dark or too light?

e. Create one or more adjustment layers (page 79) to fix the print's problems. The most useful layers will probably be Layer > New Adjustment Layer > Hue/Saturation and either Layer > New Adjustment Layer > Levels or Curves. Use the adjustment layer(s) to modify the monitor image in the direction opposite from that of the print. For example, if the print is too green, use the adjustment layer to make the monitor less green (more magenta). If the print's midtones

are too dark, make the monitor's mid-tones lighter. Make another print.

f. Compare the new print to the image on the monitor *with the adjustment layer temporarily turned off.* The secret of this shortcut is to print with the adjustment layer turned on and compare the print to the monitor with the monitor's adjustment layer(s) temporarily turned off.

g. Keep modifying the adjustment layer(s) until you have a print that is close to the monitor's image (with the adjustment layer turned off). Save each adjustment layer as a settings file: click the Save button in the layers dialog, name your settings file (put the name of the printer in the file's name), and save it on a personal diskette for later reuse.

Whenever you print a new image on the same printer, edit the image until it looks correct on the monitor. Then create an adjustment layer (or layers) and load your saved settings from your diskette into the adjustment layer. When you print, the settings in the adjustment layer(s) will *approximately* compensate for the difference between your printer and your monitor and make the print *approximately* match the monitor with the layer(s) turned off. You'll probably need to do another print to get perfect colors and tones.

This shortcut has limitations. It's not as convenient as a real color management system. If you do not use the same monitor each time it will be less effective. Also, different types of paper produce different colors, so you might need to create and save different settings for different papers.

A new technology, color management, seeks to perfect color matching. Color management synchronizes the monitor and the printer by giving the computer feedback about what colors each device produces. Apple Computer's ColorSynch software is one example of this software, which requires that color synchronization databases be made available to the computer's operating system.

Color management software works by comparing the color gamuts of your monitor and your printer, which it can do if it has a **device profile** for each of them, a software database that describes the colors that the device (monitor or printer) can create. After comparing the two profiles, the color management software adjusts the monitor so it only shows colors that the printer can create. This means that your first print will more closely match the appearance of the monitor image.

Even with color management, you will probably need to make more than one print to perfect your image. In this respect, digital printing is like darkroom printing: You make test prints in order to come closer to a final print that expresses your idea. But with color management you begin the process much closer to the end result.

Making Your Prints Match the Monitor
PRINTING IN RGB AND CMYK

RGB and CMYK are the two modes commonly used to edit color images. Some printers, especially inexpensive inkjet printers, work better if your image is edited and printed in RGB mode. These printers' built-in, automatic RGB to CMYK conversion software produces better looking prints than you will get if you edit in CMYK mode. Other printers produce better quality output from CMYK mode images. If your printer makes better prints in one particular mode, always use that mode.

When you edit in RGB mode without color management, you can use the software's Gamut Warning to locate colors that the printer cannot reproduce. When you are ready to print, choose View > Gamut Warning (in Adobe Photoshop 6). When the Gamut Warning is turned on, any colors that your printer cannot properly reproduce will be concealed behind a mask of flat color (see right). In order for the Gamut Warning to work properly, the correct printer profile must be installed. To see whether the profile for your printer is installed, look in Adobe Photoshop 5 under File > Color Settings > CMYK Setup > CMYK Model > ICC. In Adobe Photoshop 6, the command is Edit > Color Settings > Working Spaces > CMYK. Without the correct profile, Gamut Warning is not accurate.

Editing in CMYK has certain advantages. Even if your computer doesn't have a complete color management system, no out-of-gamut colors are shown on the monitor in CMYK mode. CMYK mode prohibits the monitor from displaying any color that the printer cannot reproduce. In Adobe Photoshop 5 or later the command to work in CMYK mode is Image > Mode > CMYK Color.

Gamut warnings

Above, a monitor image with out-of-gamut colors. Saturated colors will fail to print properly on offset printing presses. Note that because these illustrations are printed on an offset press, they cannot exactly represent the appearance of out-of-gamut colors on a monitor.

The command View > Gamut Warning creates a colored mask to cover the out-of-gamut colors. The underlying colors are not altered, they are simply hidden from view by the mask layer. The hidden colors are those that cannot be accurately reproduced by CMYK printing devices such as offset presses.

The image shows the results of desaturating the out-of-gamut colors. Use a selection tool like magic wand or, better, the Color Range command to select the problem colors; once they are selected use the Saturation command to decrease saturation in those colors. When they are within the gamut, the Gamut Warning will disappear. In some cases you will need to lighten or darken the colors to make them fall within the printer's gamut. Note that the inks used by desktop inkjet printers have a much greater color gamut than offset press ink has; you may not need to adjust the gamut of your image to get good prints.

PHILIP KREJCAREK Santa Fe Summer #6

A perceptive artist can overcome the limitations of ink color gamuts by understanding how the eye perceives color. Some colors, particularly blue, reproduce poorly with CMYK inks, but an artist can compensate for weak colors by using other colors in the image. The blue sky in this image does not look nearly as vivid in printed form as it does on a monitor, but photographer Philip Krejcarek made the blues *feel* stronger by placing a contrasting warm, ivory skull in the center of the image.

There may be more than one printer connected to a computer. Because the color gamut database (profile) for each printer is different, your image-editing software must be told which printer's profile to use. In Adobe Photoshop, a list of available profiles can be viewed by choosing Edit > Color Settings > Working Spaces > CMYK . In Photoshop 5 it is File > Color Settings > CMYK Setup > CMYK Model > ICC. Select the name of your printer and the type of paper that the printer is using (glossy or matte, for example).

Paper makes a difference in how your prints look. Different brands of paper react differently to ink or dyes. Inkjet papers produce the greatest amount of variation because ink seeps into the paper in different degrees. In general, papers that absorb less ink produce more brilliantly saturated colors and deeper tones. This is why all photo-quality inkjet papers are coated with a moisture-resistant white substance. Glossy paper gives rich dark tones, just as glossy darkroom paper gives tones with greater depth. Ordinary copier paper produces muted colors and dull tones because the ink soaks in freely; it may even bleed through to the other side.

Choosing the wrong paper can reduce the effectiveness of color management systems. At this time, most printer manufacturers supply color management data (profiles) only for the papers they sell. If you print on another brand of paper the color management software may not have the data profile it needs to match the monitor and the printer. See the Appendix for the names of companies that sell software profiles for nonstandard combinations of ink and paper.

Sharpening Prints

Digital sharpening accentuates the existing details in an image. It increases the *feeling* of sharpness in a print, but it cannot create detail where there is none to begin with. Most scanned images need some sharpening because the scanning process can blur fine details. The sharpening technique that is most helpful is called unsharp masking. Unsharp mask is a filter (page 91) that works by comparing neighboring pixels and increasing the contrast between them. It makes light pixels lighter and dark pixels darker, so that the contrast of fine details is enhanced. In areas of smooth, flat tone where there is no difference between neighboring pixels the filter doesn't change the pixels.

Unsharp masking gets its paradoxical name from a rarely used darkroom procedure that creates an illusion of sharpness in prints. In unsharp masking, an out-of-focus ("unsharp"), low-contrast, positive image ("mask") is made by contact printing from a negative. The two films are sandwiched together and printed with higher contrast.

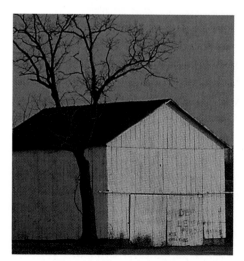

Controlling unsharp masking. In Adobe Photoshop choose Filter > Sharpen > Unsharp Mask. There are three different settings that control unsharp masking. **Amount** is strength; it controls how much the contrast between pixels is increased. **Radius** is distance; it controls how far from each pixel the effect extends. Ugly-looking effects are often caused when too large a radius is chosen. For most printed images a radius of .5 to 2 is sufficient. **Threshold** is sensitivity; it sets a requirement on the amount of contrast between neighboring pixels. If the contrast between neighboring pixels is below threshold no sharpening will occur. The range is 0 to 255. In images with skin tones, a higher threshold number is recommended to prevent unwanted skin texture. Experimentation is an essential part of learning to use Unsharp Mask.

Degrees of unsharp masking

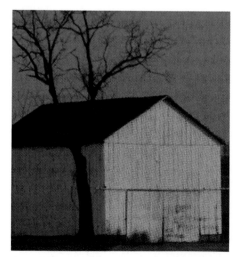

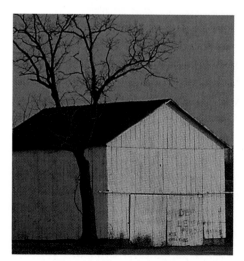

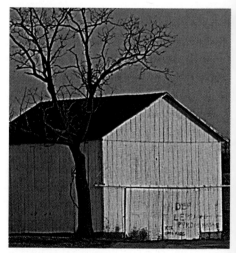

An unsharpened image printed at 300 pixels per inch.

Appropriate unsharp masking. Amount 200 percent, Radius 2 pixels, Threshold 6.

Excessive sharpening. Note the strange appearance of the tree against the sky. Amount 400 percent, Radius 4 pixels, Threshold 6.

MARILYN WALIGORE
Pure White and the More than Seven Apples

In Marilyn Waligore's image, sharpness and color saturation carry allegorical meanings. Purity is white, and thus untainted, while the forbidden fruit is always ripe and vividly red. Good and evil are always sharply distinguished; the difference between them is never blurred.

Besides using a large format camera to obtain sharper images, she pushes the sharpness to the limit with use of the unsharp mask filter.

USING UNSHARP MASKING

Before you sharpen, you must know how your image will be used. Will you make a print or put the image on the Internet? If you print it, you must know how many pixels per inch there will be in your print.

If you plan to reuse the image for a different purpose or at a different size, save an archival copy before sharpening.

1. Prepare the preview. Set the image magnification at 100 percent. Put a check mark in the Unsharp Mask dialog's Preview check box (see opposite). A check in this box lets you preview the sharpening effect across the monitor screen. When you uncheck the box it turns the preview off. Clicking it on and off repeatedly lets you compare the sharpened and unsharpened images.

2. Determine the radius. For a printed image, divide the pixels per inch in the print by 200. For example, for 180 pixels per inch, divide 180 by 200. The Radius therefore is .9. If you are printing at 300 pixels per inch, divide 300 by

200; your Radius will be 1.5. Note: Pixels per inch is not the same as the printer's dots per inch. These two terms measure different things (see page 18). Ignore the printer's dots per inch and calculate the radius using pixels per inch.

If you are preparing an image for display on the Internet or in multimedia simply use a Radius of .5

3. Determine amount and threshold. Adjust the amount first; temporarily set the threshold to 5. Try amounts between 50 and 300 percent. It's not possible to predict what the amount should be; the best amount is determined by the image's sharpness, the subject matter, and the scan's graininess. When you have decided on an amount, experiment with the threshold. If the image is grainy or if skin tones are prominent you will need to use a higher value for the threshold. Raising the threshold decreases the sharpening effect, so if you significantly raise the threshold you may need to compensate by increasing the amount.

Making Images for the Internet

The Internet is an inexpensive way to show your work. The best way to use the Internet as a showcase is to put the images on a World Wide Web site. In some ways, a web site resembles a book; you control the size and layout of the pages and help the viewer by using captions and statements that explain the pictures. Unlike a book, a web site can be easily updated; old images can be removed and new images added.

Developing a web site requires a major commitment of time. A web site requires maintenance on a monthly schedule. You probably will need to reprogram the site every few years because of technology changes. If you don't know how to program, you'll have to learn how or get someone to do it for you. Many photographers who don't want such a commitment join with others on a group web site. This distributes the cost, enabling them to hire a professional web programmer to build, maintain, and update the site. In a school you may be able to show a portion of your work on a free site sponsored by the school.

Preparing images for the Internet. Most scanned images have more pixels than a web page can display, so you usually will need to reduce the resolution of your images. Not all monitors display the same number of pixels; you will need to design your web pages to accommodate the different models. Variations among monitors can also cause visitors to see your images with the wrong brightness and contrast or with color biases. Since you cannot control the way other people's monitors display color, you can only reduce the problem by making sure that the monitor on which you develop your web images is calibrated with Adobe Gamma or equivalent software.

Dueling gammas? The monitors of Apple Macintosh and Microsoft Windows computers are set to different gammas at the factory. (Gamma is a measure of contrast.) This means that photographs look different on the two systems. Above, a Macintosh monitor; below, a Windows monitor.

You have few alternatives. Macintosh monitors are set to a gamma of 1.8, ideal for creating printed documents. Windows monitors are set to a gamma of 2.2, the U.S. broadcast television standard. You can prepare your Internet images on a monitor set with Adobe Gamma for a gamma of 1.8 or 2.2, or you can compromise and use a gamma of 2.0.

You can preview the effects of the gamma change. Choose View > Preview > Windows RGB (to preview how the image will look on a Macintosh) or View > Preview > Macintosh RGB (to preview how the image will look on a Windows computer).

Compressing images for the Internet with JPEG

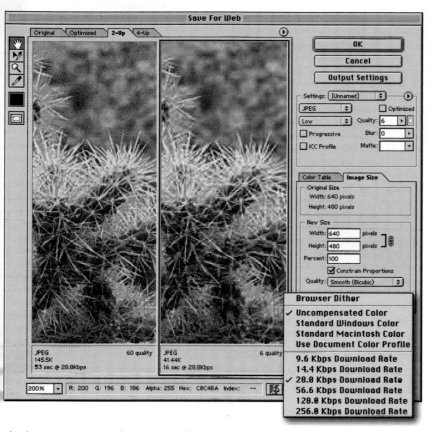

Most computers receive information sent over the Internet at a very low speed. Under typical conditions it takes a fast modem more than four minutes to deliver a full-screen, 16-million-colors image. Very few web site visitors tolerate that long a wait. File compression formats have been developed to speed up the transmission of images, and new formats are being developed (see "Recent Developments in Imaging Software" in the Appendix).

JPEG (pronounced "JAY-peg") is the only universally accepted 24-bit photographic compression format (see page 39 for more about JPEG). Research about how human vision works played a key role in developing JPEG; the creators' goal was to hide the evidence of compression from the viewers' eyes. Since we see brightness more accurately than color, JPEG is designed to minimize visible irregularities of brightness but allow large color errors. The success of the design is impressive; JPEG images compressed to 25 percent of their original size rarely show signs of compression.

Planning compression. It's a good idea to make sure your web pages (images plus text) are received by viewers in less than 30 seconds. You can estimate this by adding together the sizes of all the files on the page and dividing the total by the speed of your visitors' modems. For example, if a page totals 75 kilobytes, and an average modem downloads data at 3 kilobytes per second, the download time will be about 25 seconds. If your page takes too long to download, reduce the file size of your photos by compressing them at a lower quality level or make their pixel dimensions smaller.

The best way to speed up your web page is to use more image compression. Slow download speed is often more of a drawback to a web site than compression artifacts (visual irregularities) in its images.

The Save for Web dialog box of Photoshop 6 allows you to get the best performance from JPEG images. When you select the Save for Web command (File > Save for Web) a dialog box opens in which you can experiment with several settings to find the best compromise between image quality and download speed.

a. Click the monitor color and download rate button.

b. A pop-up menu appears. Check mark the settings you wish to use. When choosing a download rate, remember that many viewers' modems work more slowly than they are supposed to.

c. Choose how many versions of your image you wish to view. You can open two or four image windows at once; click an image window.

d. Select a JPEG quality setting for it. Do this for each window.

e. Compare the quality of the images. To approximate what you see on a monitor, compare these two images from twice your normal reading distance. Photoshop's estimate of the time it requires to download appears under each image.

Making Images for Multimedia

CD-ROM discs are an inexpensive way to distribute your images, either as a multimedia presentation or as a portfolio. CD-ROM discs store over 600 megabytes of information, enough for hundreds of images. Although you must have a special drive to write ("burn") a disc, blank, writable CD discs are very inexpensive. Writable DVD discs are a newer technology that can store many gigabytes. DVD allows multimedia presentations with thousands of images (and many audio tracks) to fit on a single disc.

It's best to start simple when creating presentations. Uncomplicated authoring software, like Microsoft Powerpoint or Kai's Power Show, lets you create a simple portfolio in which images can be browsed or viewed by category. Professional authoring software, like Macromedia Director, lets you create interactive presentations of commercial quality, but learning its advanced features takes dedication and considerable practice.

Technical considerations are much like those in preparing images for Internet distribution. You must deal with monitor calibration (Macintosh gamma 1.8 vs. Windows gamma 2.2) and screen pixel dimensions (if you assume viewers have large, million-pixel monitors, some people won't be able to view your images). File compression is less of an issue. CD-ROMs and DVDs transfer large images to the computer almost instantly; little or no compression is needed unless your presentation has thousands of images or many audio files.

Students at Wright State University in Ohio created this multimedia CD-ROM. Professor Ron Geibert's Introduction to Multimedia class worked with an art history class on a joint project to create a disc that highlights 24 contemporary art works in the university museum's gallery.

Students used Macromedia Director software to make the presentation highly interactive and to create animated buttons that simplify navigation through the sections.

A photographer's career on a disc. Professor Peggy Jones of MiraCosta College, California, created an extensive portfolio covering her nearly 20 years as a photographer. Above is the page that introduces her collection of one-of-a-kind, handmade cameras.

Making Prints on Film and Photographic Paper

Desktop printers aren't the only way to get prints from digital images. You can print directly onto traditional photographic paper or make color film transparencies and negatives from your files.

A film recorder uses a film camera to photograph the screen of an extremely high-definition computer monitor. The monitors are small (a seven inch tube size is common), but they display images of up to 8,192 x 7,022 pixels. Satisfactory 35mm slides can be made by film recorders with resolutions as low as "2K" which is 2,048 x 1,365 pixels.

If your goal is a print, you can expose black-and-white or color negative film in a film recorder and print the developed film in a traditional darkroom. You may want at least 3,000 x 2,000 pixels on the film in order to make the print look sharp.

Film recorders are RGB devices. This means that they can record an RGB image with the full color gamut. However, to get the film's tones to closely match your monitor's image you'll need to experiment, especially with color transparencies. The most common problem is a shift in the brightness of the middle tones. As a starting point, edit your files with the monitor's gamma set to 2.2. Use Adobe Gamma software to make this adjustment. Discuss the best gamma setting with the recorder's operator.

Film recorders are more complex than ordinary printers. Since you probably won't operate it yourself, it is important to ask the operators about pixel dimensions, color vs. black-and-white, gamma, acceptable file formats, and other software settings *before* you prepare your images (see "Working with Service Bureaus" in the Appendix). Because hours or even days elapse between editing the file and seeing the finished film, take careful notes about your software settings so you can determine the cause of any unexpected results.

Some printers expose computer images onto photographic papers. These machines, like the Fujifilm Pictography or the Sienna FotoPrint, develop paper in chemicals. They work like scanning cameras; the paper slowly rolls under rows of flashing colored LEDs or laser beams that expose the light-sensitive emulsions. The paper rolls through processing chemicals and emerges washed and dried.

Some photographic materials, notably Fujicolor Crystal Archive paper, have a life expectancy (the time it takes prints displayed behind glass to show fading) of up to 60 years. This is desirable because many inkjet prints can fade in one to five years, although some ink and paper combinations for inkjets have life expectancies of over a century.

edited digital image (file)

film recorder

black and white negative

color negative

color slide for projection

black and white darkroom print

color darkroom print

Digital Imaging for Nonsilver Processes

Recent years have seen a revival of nineteenth-century darkroom processes. For those who are willing to mix photographic chemicals and coat each sheet of printing paper by hand, these early processes produce prints whose color and tonal beauty cannot be equaled by computer prints or by silver-based darkroom papers.

These hand-coated papers require special printing techniques because their emulsions are not very sensitive to light. Printing with an enlarger is impossible. Contact printing with very intense light is the only practical procedure. To get large prints, therefore, large negatives must be used, either made with an 8 x 10- or 11 x 14-view camera or by enlarging ordinary negatives onto special film. As a result, useful printing techniques, such as dodging and burning and combining multiple images, are difficult or impossible—or they were until digital imaging appeared.

Digital imaging has made it easy to create large negatives. A digital file can be printed on a device that can produce an enlarged negative. There are three technologies that can be used to produce enlarged negatives.

Film recorders (page 103) can be used to expose black-and-white film up to 8 x 10 inches. By controlling the development time of the exposed film, the correct contrast, which must

KARL P. KOENIG Electrified Fence, Auschwitz, Poland. (Former Nazi concentration camp, 1999)

Karl Koenig invented a nonsilver photographic process he calls polychromatic gumoil printing. His contemporary pictures of decaying Nazi concentration camp structures bear witness to the experiences of Holocaust victims; the gumoil technique intensifies the images, giving them additional texture and emotive power.

Koenig makes a large digital positive print on ordinary computer paper or plastic. He contact prints it onto a sheet of rough watercolor paper that has been hand-coated with unpigmented gum arabic, a chemical often used in oil painting. Exposure to intense ultraviolet light creates a latent image. When developed in water the heavily exposed highlights harden to form a crust. Later, oil paints are rubbed into the image; paint is absorbed only where there is no crust. Excess paint is rubbed off, and additional hues are applied by successive bleach-etching of remaining gum and filling the newly opened spaces with other colors. The result is a one-of-a-kind image.

Inkjet printers can make enlarged negatives on sheets of transparent acetate. Most printer manufacturers sell acetate sheets.

To make a negative, begin with a normal grayscale image. When the image is satisfactory, turn it into a negative by using the command Image > Adjust > Invert.

Print the negative on an acetate sheet, then print a second copy. When the two are dry, tape them together, taking care that the images are precisely aligned on top of each other. Use this composite negative for printing on the nonsilver paper. Acetate sheets are extremely vulnerable to damage, so protect the negatives by storing them in an envelope.

If the contrast is too high, create another negative. Give this negative less contrast using the command Image > Levels. Use this negative as a replacement for one of the originals, and make a new print.

If the midtones are too dark or too light, create a replacement negative and use a levels adjustment layer to correct for the midtones' printing problem (see "Printing Without Color Management on page 94 for this technique).

be very high compared to negatives for modern darkroom paper, can be achieved.

High-quality inkjet printers can also be used to make negatives on clear acetate sheets (see opposite).

Negatives up to 34 x 44 inches, sometimes even larger, can be produced by commercial service bureaus using **imagesetters,** which are computerized machines that produce special negatives used to create ink-bearing plates for offset printing presses. This relatively inexpensive service is widely available (see "Working with Service Bureaus" in the Appendix).

Nonsilver processes present health hazards. You should take precautions to avoid touching or inhaling the chemicals of nonsilver processes. In the nineteenth century many extremely toxic chemicals were used with complete disregard for their dangers. For a discussion of the hazards of each type of printing process, and how to safeguard yourself, visit the Internet site called the Alternative Processes FAQ (see the Appendix for a listing of web sites dealing with nonsilver processes).

Software lets you stitch together images to form a seamless composite photograph that can cover up to 360 degrees. You can print the image or save it so it can be viewed on a computer as a scrolling "movie." The viewer controls scrolling with the computer's mouse, and can even zoom in on details. *For the Internet addresses of companies that produce panoramic software, see page 114.*

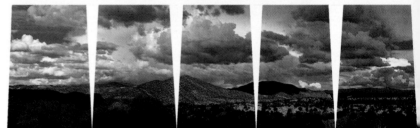

The camera does not have to be pointed at the horizon for panoramas. The wide-angle images used to create this panorama were taken with the camera pointed above the horizon line (right); the stitching software compensated for the distorted perspective (foreshortening) by slightly increasing the width of the images at the top.

The JPEG 2000 file format will enhance images seen on the Internet. JPEG 2000 evolved from the existing JPEG file format, but it will take some time for it to become widely adopted by users of web browser software. When it becomes widespread, it will make delivery of images over the Internet faster, because images can be compressed to a greater degree without further loss of quality.

JPEG 2000 has other features web site designers will want to use. Site builders will be able to embed words in the file. These words will be accessible to browsers or web search software. For example, you could include a key-word description of the subject matter (to help people who are searching the web), the date when the image was taken, and how to contact the copyright owner. Copyright notices can be hidden (in secret code) within the image data. Color profile information will be used by the software so that viewers will see more accurate colors. For example, a Macintosh will automatically correct the gamma of an image designed for Microsoft Windows.

Photographers have long dreamed of creating giant panoramas or even wrap-around, 360 degree images by stitching photographs together. Now, software that stitches pictures together makes it possible to combine images taken from a single viewpoint into large prints, animations, and interactive presentations for the Internet (see illustrations, opposite).

JPEG 2000 allows **greater compression of images.** At left, a detail from an image compressed to the maximum with JPEG. At right, the same image compressed to the same degree with JPEG 2000.

LuraTech

Equipment for Digital Imaging
COMPUTERS

Almost any personal computer manufactured since 1997 can be used for digital imaging, although some models may require memory upgrades to edit large images. Older Microsoft Windows-compatible computers that have Pentium class CPU (central processing unit) chips can be used for image editing, as can older Apple Macintosh compatible computers with PowerPC CPUs. Even computers that use Intel DX486 or Motorola 68040 chips can edit images of moderate size.

RAM (random access memory) chips hold the information that a computer is working on. Image-editing software requires much more RAM than does software like word processors and spreadsheets. A rule of thumb is that the RAM required to process an image efficiently is 2½ to 3 times the size of the image's uncompressed file. Thus, if an uncompressed image is 3 megabytes (equivalent to a color image of 1,200 x 800 pixels), it requires 7.5 to 9 megabytes of RAM for efficient processing. At the same time, a computer requires additional RAM for its own operating system software, so editing a 3 megabyte image requires a total of 15 to 30 megabytes of RAM, depending on the type of operating system software. On average, 24 megabytes of RAM is the minimum for editing color images.

Virtual memory. An image may be so large that it requires more RAM than the computer has. When this happens, the image-editing software uses virtual memory. Virtual memory is space on the hard disk that temporarily is used as RAM, permitting the computer to edit images much larger than it could normally process. The disadvantage is that it is very slow. Using virtual memory causes the image-editing software to run at only 10 to 25 percent of its normal speed.

Adding RAM. Most computers are now sold with enough RAM for basic image editing, but additional RAM can be installed. For editing moderately large images (12 megabytes), a total of 64 megabytes of RAM is adequate, especially if the computer's operating system has few RAM-consuming extra features. If possible, it is helpful to have at least 128 megabytes of RAM, as this makes it possible to efficiently edit images of 30 megabytes. Although, the cost of RAM chips fluctuates, the trend has been toward lower prices.

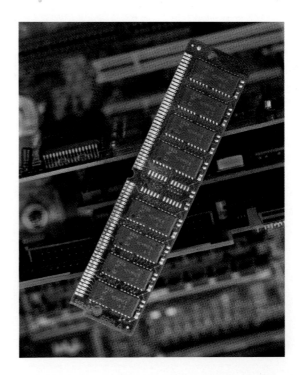

Adding additional RAM is the most effective way to increase the speed of image editing. Often computers are designed so that their owners can install the RAM chips into empty slots without specialized tools.

Eight or more memory RAM chips are usually grouped together on waferlike cards called SIMMs or DIMMs.

Be careful handling memory chips and computer parts as small amounts of static electricity will damage them. Often the sellers of memory chips will provide an electrical grounding strap to be worn around the wrist while handling SIMMs and DIMMs.

Nixon USA

Film scanners are used to digitize film negatives and color transparencies. The images made by most desktop film scanners are of excellent quality. Some approach the quality of images produced by drum scanners, the standard by which all professional scans are judged. For a desktop scanner to accurately scan color transparencies, the scanner must be able to record accurate detail in both the highlight and shadow areas of the film. Some scanners cannot. For this reason it is important to test or at least view samples of color transparency scans before purchasing a film scanner.

The Nikon Super Coolscan 4000 is a desktop scanner for 35mm film; it can produce images with nearly the resolution and color fidelity of those produced by drum scanners.

Density range is especially important in scanning film. Density range refers to the limit of the scanner's ability to capture detail in the darkest parts of film. A scanner with a density range of 3.0 can "see" detail in dark areas of film that block up to 99.9 percent of the light. Many fine-grain color transparency films have maximum densities of 3.4 or more, so a film scanner must have a density range of at least 3.4 to see all the shadow detail in these films. The manufacturer of the Super Coolscan 4000 claims that its density range is 3.6, very close to the 3.8 density range of drum scanners.

Bit depth is also important to image quality. Although the final image sent to the computer for editing usually has 24-bit pixels (16 million colors), some scanners capture 30 to 48 bits per pixel. Having more bits available during the scan allows the photographer to do significant image editing to the raw image (using the scanner's software), ensuring that when the image is converted to 24-bit format it will need a minimum of further editing.

Flatbed scanners are used to digitize printed photographs or printed artwork. They operate like copiers; the original artwork is placed on a glass plate, and a light source within the scanner illuminates the art while a moving line of CCD sensors captures the image. Capture can take from a few seconds to nearly a minute.

The operation of a scanner is controlled by software in the computer; to get excellent image quality from a scan, the photographer must preview the image and correct the brightness, contrast, and color balance settings. Fortunately, even inexpensive scanners can produce excellent image quality. Some flatbed scanners have attachments that digitize film. This is a convenient feature, but the image quality is far poorer than that from film scanners.

The UMAX Astra 3400 P is a good example of a photo-capable flatbed scanner. It can scan letter size (8.7 × 11.7 inch) graphics or photographs at an optical resolution of 600 × 1,200 samples per inch.

UMAX Corporation

Equipment for Digital Imaging
MONITORS, VIDEO CARDS, AND STORAGE

The video card controls how your images look on the monitor. The card is a combination of memory chips and circuitry that determines the pixel resolution of the monitor and the number of colors displayed per pixel.

Since 1992 all video cards have been able to display at least 640 x 480 pixels, which is adequate for digital imaging. It is better to have a video card and monitor combination that can display more pixels. Displays showing from 1,024 x 768 pixels up to 2,000 x 1,600 pixels let you see more of the image with clarity.

Although imaging software allows you to fit any large image on the screen by shrinking it, detail is lost when the image is viewed at less than 100 percent magnification. Some monitors are not compatible with all the settings a video card can provide, so you should read the specifications of monitors, especially older ones, before attempting to connect them to a new video card.

Video cards determine the number of colors that can be displayed for each pixel. Since pixels can have 16 million colors, the video card also should be able to display 16 million colors. Many older video cards cannot display that many colors, although some cards allow extra video memory chips (called VRAM or video RAM) to be added to increase the number of colors. Although 16 million colors is best, you may have acceptable results editing with as few as 32,000 monitor colors, however, smooth tonal gradations may break up into rough-looking bands of tone. These rough-looking bands only appear on the monitor; they won't appear if the image is printed. For black-and-white images, only 256 colors are needed.

Everything a computer needs, but is not processing at a particular moment, is kept on the computer's hard drive. When images are saved for later reuse, the computer stores the files on its hard drive. Because of their enormous capacity (usually thousands of megabytes), hard drives store vast numbers of files. No hard drive, however, is large enough to store all the image files that users create in a typical graphics lab, so their computers often have an auxiliary storage device, a **removable disk drive.** Removable disk drives are very convenient; they allow a student who uses a variety of computers to keep all of his or her image files together on a few disks. Removable disk drives have capacities from 100 megabytes to several gigabytes (billions of bytes).

Iomega

Zip cartridge drives from Iomega are among the most convenient ways to store and transport the files you are working on. The inexpensive cartridges contain nearly 100 or 250 megabytes of data on a rotating platter. The drive mechanism, power pack, and cable are small and lightweight enough to be carried in a briefcase. Several models of Zip drives are made. To take advantage of the Zip's ability to transfer data rapidly, the models that use SCSI or USB connections to the computer are required. Zip drives that connect to the computer's parallel port transfer data much more slowly.

Most removable disk drives use either magnetic or magneto-optical storage. The most widely used types of removable magnetic disk drives are the Iomega Zip and Iomega Jaz drives. They operate on a principle similar to the one used by hard disks, with spinning platters on which microscopic spots are magnetized or demagnetized to represent the 1s or 0s that computers understand. Magneto-optical disks, like the Fujitsu DynaMO and Pinnacle Micro, operate more slowly, but the life expectancy of their data is longer, and the data is not vulnerable to accidental damage by magnetic fields.

Archiving images. When your image editing is complete, a good way to make long-lasting and inexpensive archival copies is to transfer the file onto a CD-ROM disc. Ordinary CD-ROM drives can read but not write discs, but some CD drives, called CD-Recorders, can write up to 650 megabytes of files onto a blank disc in an operation called "burning a disc." CD-ROM discs are optical discs and have a life expectancy of many decades. CD-Recorders can burn a disk only once; the disc cannot be erased or rewritten. Rewritable CD drives and rewritable discs are also available, but they are not as economical for long-term storage, and their discs cannot be played back on all CD-ROM drives. For those cases where the large capacity of a CD-ROM is not enough, the newer DVD recorders can write nearly ten gigabytes of files onto a DVD optical disc.

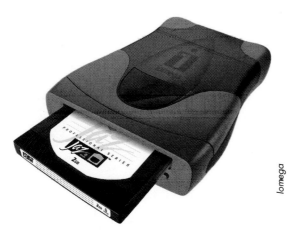

Iomega

Iomega

If you have a large numbers of big image files, you may require a larger capacity drive than the Zip. Iomega Jaz drives have capacities of 1 to 2 gigabytes. These drives also operate much faster than Zip drives, approaching the speed of the hard drives built into computers.

CD-Recorders can store 640 megabytes of images for the cost of a few sheets of photographic paper. Using special blank discs, these drives create permanent, nonerasable CD-ROMs that can be read by any computer's ordinary CD-ROM drive. While their slow speed and inability to erase and rewrite files makes them unsuitable as a primary storage medium, their decades-long life expectancy makes them an excellent choice for archiving images.

Equipment for Digital Imaging
PRINTERS

Nothing in digital imaging has improved as rapidly as color printers. The biggest improvements have been among inkjet printers, which create images by spraying nearly microscopic droplets of colored inks onto paper (see also IRIS printers, opposite). Dye-sublimation printers, however, create the highest quality photographic output because each dot they print can be any of the 16 million colors in an image. Color laser printers are the speediest printers, and their cost per print is the lowest, but their image quality is not as good.

The permanence of digital prints is a source of concern to artists. Unlike traditional darkroom prints, which can be displayed for 15 to 60 years before noticeable fading occurs, most digital prints begin to fade in six months to five years. Permanence issues are now being addressed by the manufacturers of ink and paper for desktop inkjets.

Inexpensive inkjet printers. The Epson Stylus Photo 870 produces prints indistinguishable from traditional darkroom prints. Inkjet printers use near-microscopic ink drops (up to 1,440 x 720 drops per inch) and six inks to achieve smooth-looking tonal gradations. There are two cyan inks, two magenta inks, a yellow ink, and a black ink. The expensive inks used in inkjet printers produce a much wider color gamut than the inexpensive inks used in offset printing presses.

Inkjet printers use a variety of papers, including some that resemble photographic paper. Some glossy papers produce darker blacks and more saturated colors than matte paper.

Inkjet printers have some disadvantages. An 8½ x 11 image may take more than five minutes to print. Because 16 million colors must be simulated with only six or fewer ink colors, the printer "dithers" (mixes a variety of colored dots in one small area). As the printer's paper-feed mechanism begins to age, small dark and light bands may appear on prints.

Laser printers like the Minolta Color PageWorks are the fastest printers, capable of printing a page per minute. Laser printers use dry colored powder (toner), which is fused to the paper by heat, at up to 600 x 600 dots per inch.

Disadvantages are in the print quality, currently poorer than inkjets, with bands and streaks of uneven color density reducing the photo-realism.

MINOLTA-QMS

Dye-sublimation printers like the Olympus P-400 are the most photo-realistic printers. A dye-sublimation printer uses heat to vaporized tiny amounts of colored dye. The vaporized dye cools and condenses on the paper to form a colored spot. Because all three colors can be deposited on a single spot, and because the amount of dye is controlled by the amount of heat, each dot can be any of 16 million colors. Because there is no need to dither pixels, a dye-sublimation printer that produces only 200 dots per inch can be photo-realistic.

Dye-sublimation printers have drawbacks. An 8½ x 11 print can take up to 10 minutes to print, and the print can cost several dollars because the color-bearing ribbons are expensive.

Working with Service Bureaus

Improved Technologies

Grahm Nash of Nash Studios with one of his IXIA (Iris) printers. Iris printers are high-quality inkjet printers that produce prints on wide rolls of paper. Favored by fine-art photographers, they are exceptionally adaptable. Many kinds of paper and ink combinations can be used, giving artists an almost unlimited choice of paper textures and color palettes. Some combinations of ink and paper produce prints with life expectancies of over 100 years. A few service bureaus have built international reputations for the quality of their Iris prints and are sought out by some of the leading digital artists.

CreoScitex

Digital imagesetter machines produce negatives used to create the ink-bearing plates used in offset printing. Photographers use them to create enlarged negatives that have the high contrast and high density required by such nonsliver printing processes as Platinum, Palladium, and gum-oils.

Service bureaus are companies that provide computer graphics services. In many places, a service bureau is the only source for high-quality digital printing or very large Iris prints on sheets or rolls of paper. Service bureaus often have film recorders (see page 103) that create slides or negatives from digital files, as well as imagesetter machines for creating the enlarged black-and-white negatives that are necessary for nonsilver printing processes (see page 104).

Service bureaus will have a list of approved delivery media, such as Zip or Jaz disks, Syquest cartridges, CD-ROM discs, and possibly others. Some permit you to send files to them by modem, either to a web site or directly to the company's modem.

A service bureau will have specific requirements about what software may be used to save your files, as well as the number of colors, dimensions, dots per inch, and file format used and possibly other specifications.

All of these requirements must be discussed with a sales representative before you begin to work with the service bureau. It is also important to carefully specify the way you wish to receive output. For example, if you are ordering enlarged black-and-white negatives from an imagesetter you must specify the desired maximum density to ensure that the contrast is suited to your nonsilver printing process.

Internet Resources for Photography
Sites for materials, technical help, and critical ideas

Many companies, organizations, and individuals maintain photography-related sites on the World Wide Web.

The sites listed here include many that are useful to students who wish to learn more about topics covered in this book. Some sites provide an introduction to issues of general concern to photographers and artists, including art theory and art criticism. Other sites are commercial and are maintained by the manufacturers of photographic materials. Search and link sites lead to hundreds of additional photography sites.

Software that searches for photographic topics; sites with links to other photography sites

Artnet, commercial site, index of artists, exhibitions, and galleries
http://www.artnet.com

Artsource, art news and links to the art world
http://www.uky.edu/Artsource/experimental.html

Bengt's Photo Page: an encyclopedic collection of links to photographic sites
http://www.algonet.se/~bengtha/photo

Yahoo's photography search page
http://dir.yahoo.com/Arts/Visual_Arts/Photography

Institutions and schools with photographic collections

California Museum of Photography
http://cmp1.ucr.edu

International Center for Photography, New York City
http://www.icp.org

Library of Congress American Memory site, vast archives
http://memory.loc.gov/

School of Visual Arts/ Digital Salon
http://www.sva.edu/salon

Visual Studies Workshop
http://www.vsw.org

Photographic galleries

Fixing Shadows
http://www.people.Virginia.EDU/~ds8s/

Helen Golden/ Unique Editions
http://www.911gallery.org/911 Gallery, Digital Photography

Hubble Space Telescope Gallery
http://www.stsci.edu/pubinfo/Pictures.html

Pictures of the Year, winning images from a major photojournalism competition
http://www.poy.org

Time-Life Photo Collection, images from the Time Inc. Picture Collection
http://www.thepicturecollection.com

Zone Zero, a gallery with a brilliant, radical outlook
http://www.zonezero.com

Online publications: arts, arts criticism, documentary photography, and commercial photography

Aperture magazine, fine arts photography
http://www.aperture.org

Blindspot Magazine
http://www.blindspot.com

Critic A. D. Coleman's photography columns at Nearby Cafe, an online salon
http://www.nearbycafe.com/adc/adc.html

Photo District News, for advertising and corporate photographers
http://www.pdn-pix.com

Photo-Electronic Imaging, general news of electronic imaging, Photoshop tutorials
http://www.peimag.com

Publish RGB/Online, magazine for electronic
publishing professionals
http://www.publish.com

Photographic associations

American Society of Media Photographers,
association of professional photographers
http://www.asmp.org

College Art Association
http://www.collegeart.org

International Association of Fine Art Digital
Printermakers
http://www.iafadp.org

National Press Photographers Association
http://www.nppa.org

SIGGRAPH: an association of computer
graphics professionals
http://www.siggraph.org

Society for Photographic Education, the
national organization of photography
instructors. This site contains excellent
educational material and many links.
http://www.spenational.org

Copyright issues & the social use of images

Adbusters, promoting freedom from media
thought control
http://www.adbusters.org/

Columbia University Law School, the ILT
Guide to Copyright
http://www.ilt.columbia.edu/text_version/
projects/copyright/

Sources for nonsilver photography

The Alternative Photographic Process
FAQ page
http://duke.usask.ca/~holtsg/photo/
faq.html

Bostic and Sullivan: A vendor
of alternative process supplies;

extensive how-to information on alternative
processes
http://www.bostick-sullivan.com

Digital imaging: technical information

Adobe Tips and Techniques
http://www.adobe.com/products/tips/
photoshop.html

Wilhelm Imaging Research, Inc., researches
the longevity and stability of photographic
and digital film and prints
http://www.wilhelm-research.com

Online instruction about web authoring

lynda.com
http://www.lynda.com

Sources for panoramic imaging software

Apple Computer: Quicktime VR
http://www. Apple.com

Enroute Imaging: Powerstitch, Quickstitch
and Quickstitch 360
http://www.enroute.com

Live Picture: PhotoVista
http://www.livepicture.com

PanaVue: Visual Stitcher
http://www.panavue.com

A source for color profiling software (ICC profiles) for inkjet printers, papers, and inks

Cone Editions Press/ Inkjet Mall
http://www.inkjetmall.com/store/
products.html

Sources for archival inks and specialty inkjet papers

MIS Associates, inks and papers
http://www.inksupply.com

The Stock Solution, inks and papers
http://www.tssphoto.com/sp/dg/

Internet Resources for Photography

Sites for buying and selling computer equipment

CNET, a computer shopping guide
http://www.computers.com

Pricescan, a price guide with an extensive computer section
http://www.pricescan.com

United Computer Exchange, for buying and selling new and used computers
http://www.uce.com

Sources for photographic hardware and supplies

Adobe, imaging software
http://www.adobe.com

Adorama, a large mail-order supplier
http://www.adoramacamera.com

B&H Photo-Video, a large mail-order supplier
http://www.bhphotovideo.com

Canon, cameras
http://www.usa.canon.com

Corel, imaging software
http://www.corel.com

Epson,digital cameras and printers
http://www.epson.com/northamerica.html

Fuji, cameras and film
http://www.fujifilm.com

Hewlett-Packard, digital cameras and printers
http://www.hp.com

Ilford, film
http://www.ilford.com/html/us_english/homeng.html

Iomega, removable storage devices
http://www.iomega.com

Kodak, cameras and film
http://www.kodak.com

Minolta, scanners and cameras
http://www.minolta.com

Nikon, scanners and cameras
http://www.nikonusa.com

Olympus, scanners and cameras
http://www.olympus.com

Pentax, cameras
http://www.pentax.com/home.html

PhaseOne, large-format digital camera backs
http://www.phaseone.com

Polaroid, scanners, cameras, and instant film
http://www.polaroid.com

Sony, digital cameras
http://www.sony.com

1-BIT COLOR A system for creating raster (bit map) images on a computer in which each pixel uses only one bit of memory and disk storage. In 1-bit color, a pixel is either black or white.

8-BIT COLOR OR 8-BIT GRAYSCALE A system for creating raster images in which each pixel uses one byte of memory and disk storage. This produces 256 colors or shades of gray, which is enough for a high-quality black-and-white image or a low-quality color image.

24-BIT COLOR A system for creating raster images in which each pixel uses three bytes of memory and disk storage. In RGB color one byte is used by each of the red, green, and blue components (channels) of a pixel.

ADDITIVE COLORS Red, green, and blue are the additive colors of film-based photography and digital imaging. When red, green, and blue lights are mixed in equal amounts the result is white light.

ALIASING In a digital image, the appearance of jagged, "staircase" effects along lines and edges, especially diagonal lines. Aliasing is accentuated when the pixels in the image are highly enlarged and visible to the viewer.

ALPHA CHANNEL In Adobe Photoshop software, the palette where masks are stored.

ANALOG TO DIGITAL CONVERSION The process of converting the analog information captured by a scanner or camera into computer-readable form. The analog signal is translated into digital numbers by a computer chip.

ANTI-ALIASING The process of reducing jagged, aliased edges by smoothing (gently blurring) pixels along the edges.

ARCHIVAL IMAGE An image on paper or film that can be displayed behind glass for many decades or more without any noticeable fading.

ARTIFACT Any visible degradation of the details of a digital image caused by the methods used to capture, store, or compress the image. A common form of artifact occurs during lossy compression when bogus details appear near the edges of objects. In other artifacts, bands of solid colors appear in places that should exhibit subtle gradations.

BANDING An artifact that spoils the appearance of an image's subtle gradations of color and tone. In banding, bands or blocks of solid color appear in place of gradations.

BINARY NUMBER A number that is the result of changing information into computer-readable form. A binary number is composed of one or more single digits each of which can represent either 1 or 0. All information in a computer is stored as binary numbers.

BIT A single digit of a binary number, a quantity representing either 0 or 1.

BIT DEPTH The number of bits used to represent the color of each pixel.

BIT MAP An image made up of rows and columns of pixels. Also called a raster image. Each pixel represents a spot of solid color.

BRIGHTNESS (VALUE) In digital images, numerical value of a pixel that represents its brightness level from black to white. In gray scale images it ranges in value from 0 (black) to 255 (white). In color images, it is a combination of the values of each color channel. Brightness is one of the three terms that are used to exactly describe a color (the others are saturation and hue).

BRUSH An imaging software tool that paints colors or special effects on a layer.

BYTE In a computer, an organized grouping of eight bits of memory or storage. A byte is often used to represent the brightness value of a single pixel in a gray scale image or a single character (number or letter) in word processing.

CALIBRATION The act of adjusting the brightness and colors of one device, such as a monitor, to match those of another, such as a printer. Calibration may also be used to simply adjust a device to some standard of performance.

CD-ROM (COMPACT DISC, READ-ONLY MEMORY) A non-rewritable compact disc used as a storage medium for digital data.

CD-RW (COMPACT DISC, RE-WRITABLE) A rewritable compact disc.

CCD In a digital camera, a charged-coupled device (CCD) is a light-sensitive silicon computer chip that converts the light from the camera lens into electrical current. The chip may have millions of separate sensors, each of whose current reading is translated (by an analog to digital converter) into a digital brightness value.

CLIPPING In image capture with a scanner or digital camera, an exposure error that causes a loss of information at the highest and/or lowest brightness levels.

COLOR CAST An unwanted color tint to an image caused by exposure of the film or digital capture under inappropriate lighting conditions.

COLOR CHANNEL One of the ways information is organized within an image. Color channels store the brightness values of the pixels in each of the primary colors. Contrast with alpha channels.

COLOR MANAGEMENT A software system designed to deliver accurate color calibration and consistent color matching between computer monitors, scanners, and any output devices such as printers and offset presses.

COLOR SPACE A scientific description of a set of colors. A color space numerically describes all the colors that can be created by a device such as a camera or a printer.

CONTINUOUS TONE PRINTER A color printer whose smallest color markings can be any of millions of distinct colors. Dye sublimation printers are the most common type of continuous tone printer.

CMY Cyan, magenta, and yellow are three subtractive color primaries. Used by some printing processes, notably color photographic paper.

CMYK Cyan, magenta, yellow, and black are the colors used in offset printing. Although CMY ideally would be a better set of inks for printing, adding K (black) is a practical necessity because CMY inks do not produce satisfactory black tones by themselves.

COMPRESSION A software process in which image data is "squeezed" to reduce the size of the image file. Compression methods can be lossless, as in compressed TIFF images, or lossy, as in JPEG compression.

DATA Anything put into, processed by, or stored in a computer. Data can also be the input from a camera or scanner or the output to a computer accessory, such as a printer or modem.

DEFAULT A predetermined setting in a computer program which will be utilized unless the user chooses another.

DEVICE PROFILE A database used by color management software. It contains information about the actual colors that a device (for example a monitor or printer) produces. The color management software uses the information to ensure that the device produces the desired colors.

DIGITAL CAMERA A camera that captures an image on a CCD chip and digitizes it so it can

be downloaded to a computer or a digital printer.

DIGITAL IMAGE An image created by a digital camera or a computer scanner. Digital images are composed of pixels.

DIGITIZATION The process of converting analog information into digital data that a computer can use.

DISC AND DISK Terms used to describe computer media that store data on a revolving platter. Magnetic storage media are called disks (floppy disks, Zip disks and hard disks) while media that use lasers (CDs and DVDs) are called discs.

DITHERING A process used by some types of printers to create the appearance of millions of distinct colors from as few as four basic (CMYK) colors. In dithering, nearly invisible dots of each basic color are placed so close together (and the basic colors mixed without any visible pattern) that the eye is fooled into seeing a solid distinct color at that spot. Inkjet printers are the most common dithering printer.

DOWNLOAD To transfer files or other data from one piece of computer equipment to another.

DPI Dots Per Inch. Originally, a measurement of the resolution of a printer or monitor. A printer that can print 1440 dots in a row in a single inch is a 1440 DPI printer. DPI is often used interchangeably with other more accurate terms: Pixels per inch is a measure of the number of pixels (lined up in a row) per inch that appears on a monitor or in a print. An image may have only 200 pixels per inch but the printer may use 1440 dots per inch to represent those 200 pixels per inch. Thus the resolution of the printer (1440 DPI) is not the same as that of the image that it prints (200 PPI). Confusion results when DPI is used interchangeably with pixels per inch. Consider how difficult it would be to understand the following sentence if you substitute "dots per inch" for the words "pixels per inch": "An image may have only 200 pixels per inch but the printer may use 1440 dots per inch to represent those 200 pixels per inch."

Samples per inch is the number of times per inch that a scanner samples an image. Note, however, that if a scanner records 2,000 samples per inch, but its software enlarges the image by 10 times, the final image will have only 200 pixels per inch.

Screen lines per inch is used in the offset printing industry to indicate the number of rows or columns of halftone dots that appear in each inch of the printed matter. Confusion results from the fact that these halftone dots are "megadots" composed of clusters of tiny dots. Thus, an imagesetter machine may print 2540 dots per inch (tiny dots) but produce a print with only 133 screen lines per inch (megadots).

DVD, DVR, DV-RAM, ETC. A family of optical storage discs which offer higher capacities (many gigabytes) than the CD-ROM.

DYE SUBLIMINATION PRINTER A high quality, continuous tone color printer. Each multicolored dot is created when dyes of the basic colors are vaporized and then condensed on a precise location on the printing paper or plastic sheet. Because the amount of vaporization is highly changeable, each condensed dot can be any one of 16 million colors, and is thus called a continuous tone.

EXPOSURE LATITUDE The ability of films or digital cameras to accurately record a range of brightness values in the scene being photographed. A film that can accurately record scenes with extremely large brightness ranges (for example, very bright highlights and very dark shadows) is said to have a wide exposure latitude.

EXPORT The process of transferring data from one program (for example, Adobe Photoshop) to another (for example, Adobe Illustrator).

FILE A collection of data, such as an individual image, saved on a computer storage device, and given a name to assist retrieval.

FILE FORMAT The unique and systematic way in which information is organized in a file. Formats differentiate one kind of file from another. Some common image file formats include TIFF, JPEG, and Photoshop.

FILM RECORDER A device that records a digital image onto photographic film.

FILM SCANNER A device that converts images from photographic film into digital form so they can be stored in a computer and edited by software.

FILTER In imaging software, a filter is a command that will produce special effects in an image. There are hundreds of filters available as plug-in software for Adobe Photoshop.

FLAT BED SCANNER A digital scanner in which the object to be scanned is held flat on a glass plate while the imaging sensor (usually three CCDs) moves under it. A flatbed scanner can be used as a camera to record 3-dimensional objects placed on its glass plate.

GAMUT The entire range of colors that a device (for example, a digital camera or a printer) can record or reproduce.

GIF Graphic Interchange Format, an image file format. GIF is an older, bit map file format. It is an 8-bit format, so GIF images have only 256 colors. It is the standard format for creating non-photographic graphics for use on the Internet.

GIGABYTE (GB) A measure of computer memory, disk storage, or file size consisting of approximately one billion bytes (a thousand megabytes). The actual value is 1,073,741,824 bytes.

GRAY SCALE IMAGE A digital image containing only black, white and shades of gray.

HALFTONE A method of creating images on paper using a grid of ink dots of various sizes to simulate shades of gray in a photograph. For color printing, four grids of colored dots (using the colors CMYK) are printed. Newspapers and magazines use the halftone process to reproduce images.

HUE One of the three terms used to exactly describe a color (the others are brightness or value and saturation). Informally, hue is the name of the color, for example, red or green-yellow. In a 360 degree color wheel the hue can be exactly specified as one of the points on the outside of the wheel.

IMPORT The process of bringing data into a program from another program. For example, the images created by many kinds of scanner software are imported into Adobe Photoshop.

INK-JET PRINTER An ink-jet printer creates images out of millions of nearly invisible colored dots. The dots are created by squirting ink through extremely small nozzles. See also dithering.

JPEG Joint Photographic Experts Group. A software procedure that compresses files. JPEG is a "lossy" compression algorithm that degrades image quality, although the apparent effect is small unless the image is highly compressed.

JPEG 2000 A revision of the JPEG image compression standard. Along with slightly improved

image quality, new features permit images to be viewed with greater color accuracy and allow encoded copyright protection, as well as embedded keywords to assist Internet searches.

KILOBYTE (KB) A measure of computer memory, disk storage, or file size consisting of approximately one thousand bytes. The actual value is 1024 bytes.

LASER PRINTER A computer printer that uses laser copier technology to print from computer data. Printing is much faster than with inkjet and dye-sublimation printers, but image quality is often compromised by banding.

LAYER A software feature that permits an image to contain a number of separate images, viewed as though they are stacked upon each another. Some software allows specialized layers such as adjustment layers, which contain no visible images but contain commands that change the tones and colors of the layers below, or type layers, which contain editable letters and numbers.

LCD PANEL Liquid Crystal Diode. Many digital cameras have illuminated LCD screens that are used as viewfinders. They also permit the editing of pictures after they have been captured.

LOSSLESS COMPRESSION A file compression technology that reduces the size of files in ways that result in the original file being intact after decompression. There is no loss of the original data. TIFF compression is lossless.

LOSSY COMPRESSION A file compression technology that reduces the size of files in ways that result in permanent changes to the original file after decompression. Depending on the degree of compression used, the image may exhibit noticeable artifacts. JPEG compression is lossy.

MARQUEE An outline of moving dashes that appears on the monitor to show the boundaries of selected areas within an image. See also selection.

MASK An image editing tool used to limit the effects of image editing to certain areas of the image. Masks appear on the monitor as overlays of color. Unlike a selection, masks can be stored and can be edited for later reuse. Masks are stored in the channels palette.

MEGABYTE (MB) A measure of computer memory, disk storage, or file size consisting of approximately one million bytes. The actual value is 1,048,576 bytes.

MEGAPIXEL CAMERA A digital camera whose CCD chip has over one million individual sensors. Each sensor usually creates one pixel in the camera's images.

MODEM Modulator/demodulator. A device that converts outgoing digital data into analog signals for transmission over telephone lines, and digitizes incoming analog signals.

NETWORK A group of computers connected electronically so they can exchange data and share peripheral devices, such as printers and modems.

PALETTE On a computer monitor, a software component that appears as a box containing icons of tools and controls that modify the way tools operate (options). A command center for image editing tools.

PHOTOCD, PICTURECD Kodak scanning services available from many photography stores and mini-labs. PhotoCD Master scans offer high quality images from 35mm film with resolutions up to 3,072 x 2,048 pixels. Less expensive PictureCD scans of 1,536 x 1,1024 pixels are saved as JPEG files.

PIXEL Picture element. The smallest visible component of a digitized image, the basic dot which contains a single color.

PLUG-IN A small, specialized software program that is opened and operated by image editing software, and closed when its task is finished. For example, scanner software is used to capture and import images, and filters are used to modify the image. Plug-ins may be manufactured by companies unconnected with the manufacturer of the imaging software.

PPI Pixels Per Inch. See DPI.

RAM Random Access Memory. The silicon chips that are used to contain the computer's memory. The memory is used to hold and process the software programs, data files, and commands that the computer is currently using. Generally, the more RAM that a computer has for image processing, the more quickly the editing can be accomplished.

RASTER IMAGE Raster images (also called bit maps) are made up of rows and columns of pixels.

RESAMPLE To change the pixel dimensions of an image. For example, to downsample an image from 2,000 x 1,000 pixels to 500 x 250 pixels, or to upsample an image from 400 x 600 to 800 x 1,200. Resampling permanently alters the image.

RESIZE To alter the physical size of an image (how big it is printed or how large it appears on the monitor) without resampling its pixels.

RESOLUTION Resolution determines the apparent sharpness of an image. Resolution is the number of pixels per inch (or other measure, like millimeters) in an image. For example, an image printed 8 x 10 inches with 200 pixels per inch will appear much sharper than an 8 x 10 print printed with 30 pixels per inch.

When the capabilities of printers are discussed, the resolution of the printer is described as the number of dots per inch that the printer can put on the paper. See DPI.

RGB Red, green, and blue; the primary additive colors of photography and digital imaging. Computer monitors create images using the RGB colors.

SAMPLE PER INCH See DPI.

SATURATION The degree to which a color is pure and undiluted by light of a different hue. If a color is 100 percent saturated, it contains no light of another hue. If a color has no saturation, it appears gray, with no apparent hue. One of the three terms used to exactly describe a color (the others are brightness or value and hue).

SCANNER A device that converts photographs (on film or on paper) into digital form so they can be stored in a computer and edited by software.

SCREEN LINES PER INCH OR LINES PER INCH Used in the offset printing industry, lines per inch refers to the number of rows or columns of halftone dots (a "screen") appearing in each inch of the printed matter. Do not confuse screen lines per inch with dots per inch (see DPI).

SELECTION A part of the area of a digital image that has been isolated from the rest of the image for the purposes of editing operations, such as changes to color or tones. A variety of software tools are used to indicate to the computer which area is to be selected.

SERVICE BUREAU A retail business that offers a variety of computer-related services. Many have

extensive imaging capabilities, such as scanning, printing, and rental computers with imaging software. Some offer offset printing services that may include the production of large negatives.

SUBTRACTIVE COLORS Cyan, magenta, and yellow are the subtractive colors of photography and digital imaging. When equal amount of cyan, magenta, and yellow inks are mixed on a sheet of white paper, a gray or black tone results.

TIFF Tagged Image File Format. A file format for bit-map images that is readable by all major imaging software programs. TIFF allows moderate amounts of lossless compression.

UNSHARP MASKING A software process which increases the apparent sharpness of an image. Actual image detail is not increased.

VECTOR IMAGE An image formed without pixels. Lines and solid-filled areas are created by specifying the location of line end points and the positions of lines (straight or curved) between them. Adobe Illustrator creates vector graphics, and there are some vector elements (such as paths) in Adobe Photoshop that coexist with the bit map features.

VIRTUAL MEMORY Disk space on a hard drive that is used as a substitute for RAM by image editing software when the software runs out of real RAM. Because hard disks operate more slowly than RAM, using virtual memory slows the computer down.

Index